WILD AND BEAUTIFUL
SABLE ISLAND

Sand, Seals, Wild Horses, and Shipwrecks
NOVA SCOTIA, CANADA

Pat & Rosemarie Keough

A NAHANNI PRODUCTION

Published in Canada by Nahanni Productions Inc.
RR #1 Holmes Road C-7, Fulford Harbour, British Columbia V0S 1C0

Canadian Cataloguing in Publication Data

Keough, Pat, 1945 -
 Wild and Beautiful Sable Island: Sand, Seals, Wild Horses and Shipwrecks
ISBN 0-9692557-3-X
1. Natural history — Nova Scotia — Sable Island — Pictorial works.
2. Sable Island (N.S.) — Pictorial works.
3. Sable Island (N.S.) — History.
I. Keough, Rosemarie, 1959 - II. Title.

FC2345.S22K46 1993 779'.3'0971699 C93-090178-9
F1039.S13K46 1993

Printed and bound in Japan.

The authors express their appreciation to the following corporations and agencies who have been instrumental in the creation and success of the Keoughs' projects:

Apple Computer Inc. - Wayne Arcus
Atmospheric Environment Services - Gord LeBlanc, Jerry Forbes
Canadian Airlines International Inc. - Jack Lawless, Dennis Erickson
Canadian Coast Guard - John Major
Kodak Canada Inc. - Peter Scarth, David Bishop
Lowepro - Uwe Mummenhoff, Michael Mayzel
Nikon Canada Inc. - Hideo Fukuchi, Larry Frank
Tilley Endurables Inc. - Alex Tilley

Canadian Airlines Kodak Canada Canadian Coast Guard

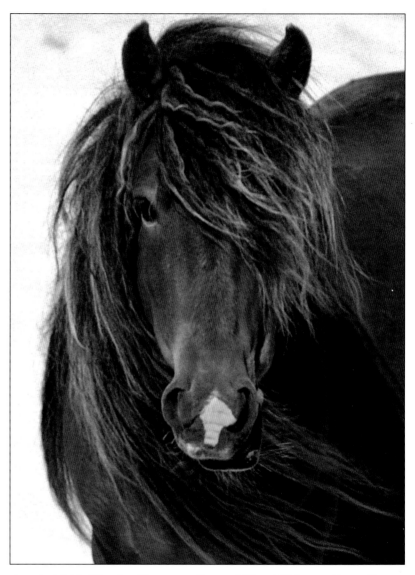

A typical Sable Island stallion, one of some 165 to 360 horses (depending on the year) that range as free as the breezes buffeting their remote island home.

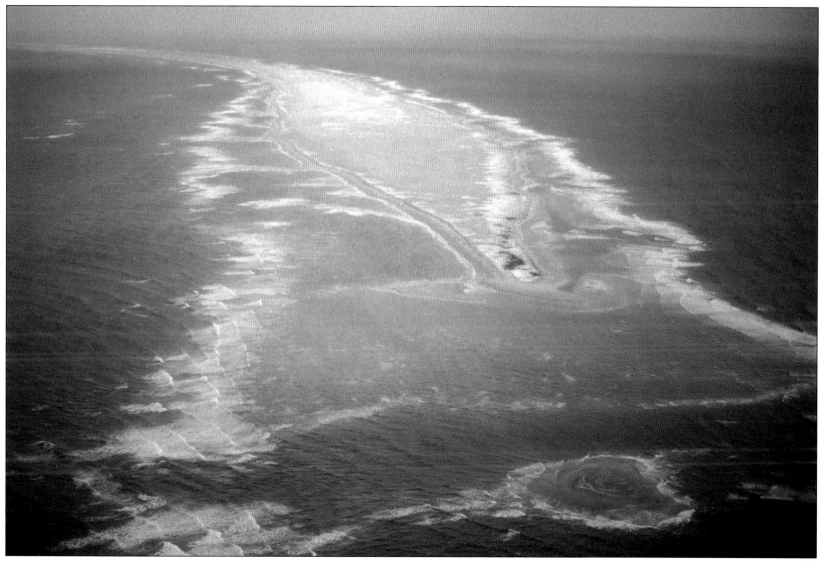

Scoured by current, wind, and wave, Sable Island is seen in a view eastward over West Spit. Frequently shrouded by mist and tempest, the island's foam-flecked bars and hidden shoals were for centuries the scourge of mariners, the icy "Graveyard of the Atlantic" for hundreds of ships and thousands of sailors.

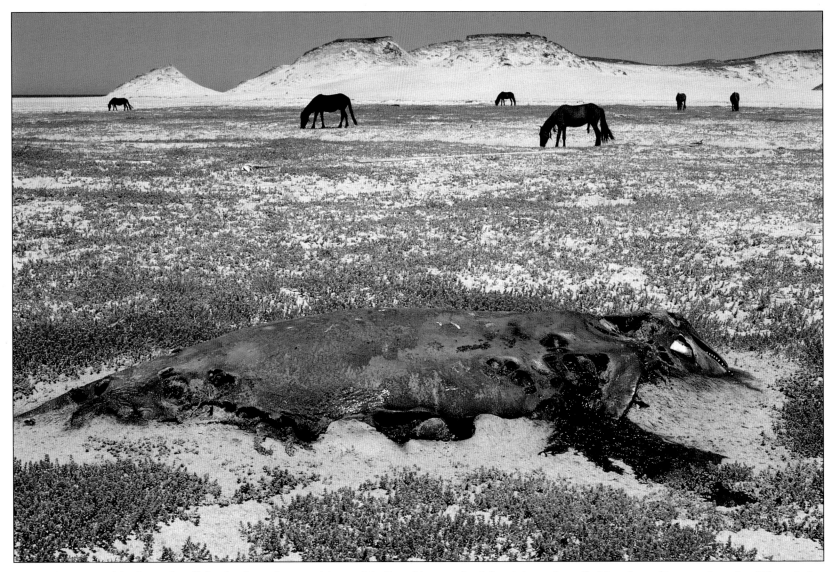

Everywhere on Sable the cycle of life, death, and renewal is graphically evident — both by sight and smell. Near Long Dune a decaying Pilot whale, stranded during a violent winter storm, adds life-giving nutrients to the salt-tolerant sandwort. Nearby a gang of wild horses peacefully grazes.

Out in the storm-tossed Atlantic, 160 kilometres southeast of the nearest landfall on the Nova Scotia shore, there lies a will-o'-the-wisp, frequently fog-enshrouded sandbar named Sable Island. In times past, before the advent of radar and other modern aids to navigation, the mere mention of this crescent-shaped sliver of land was enough to strike fear into the heart of even the most seasoned of sailors. "The Graveyard of the Atlantic," they called it; and with just cause. Through the centuries, from the time of its discovery by the Portuguese in the 1500s to recent years, Sable's conflicting currents and treacherous, tentacle-like bars and shoals have snared and doomed hundreds of proud ships. These vessels and the thousands of luckless seafarers who travelled in them lie buried beneath the ever-shifting sands of this fateful island.

Sable, that "dark isle of mourning," loomed large in the consciousness of early mariners travelling the increasingly busy sea route between Europe and the New World. They were well aware of Sable's capricious characteristics: an island friendly enough in calm weather but illusionary and deadly in foul. Such was the perceived magnitude of the obstacle posed by the island that a circa 1548 map by Giacomo Gastaldi erroneously depicts Sable as a lengthy rampart guarding much of the eastern coastline of North America. By contrast, 19th-century opinion held that the island "writhed" and "crouched," low, colourless, and unseen on the horizon, owing to a lack of both trees and high promontories.

How then did this relatively small, 42-km long by 1-km wide, windswept sandspit with its seals, wild horses, and a big reputation for disaster come to be?

Sable Island (*le sable* meaning sand in French) is the apex, the only emergent portion of a large accumulation of sand and gravel originally deposited by retreating Wisconsin glaciers between 16,000 and 45,000 years ago near Sable Island Bank, a 250 km by 115 km submerged shallow plateau located at the outer margin of the Continental Shelf. Tides, currents, and winds winnowed this glacial outwash, with grains of ancient quartz, garnet, and magnetite sand being redeposited on the bank in the vicinity of present-day Sable Island. This mountain of sand, extending down to a depth of roughly 40 metres below sea level, is underlain by bedrock, which in recent years has been actively drilled for its hydrocarbon deposits.

During the last period of continental glaciation, Sable was likely free of ice and, in size, was probably as large as the entire bank. However, as the climate warmed about 13,000 years ago and glaciers melted, the sea level rose significantly. The island was inundated to such a degree and continuously cut away by heavy seas so that eventually only a small area remained high and dry, fringed by countless shoals — the nemeses of sailors in historic times.

The obvious physical dangers presented by Sable are compounded by the fact that two major ocean currents sweep by the island: the warm Gulf Stream from the south and the frigid Labrador Current from the north. The mixing of associated hot and cold air creates thick fog banks, which blanket the island for an average of 125 days a year. In that bygone age when sextants and dead-reckoning were the sole means of navigation, Sable's fog and strong currents together with numerous violent storms served to confuse the best calculations and thwart the efforts of many a captain and crew. Ships literally ran into or were driven up on Sable, where most were quickly destroyed by pounding waves and sucking sand.

As the grisly toll of death, wrecked ships, and lost cargoes mounted, government and public concern led, in 1801, to the

founding of the Sable Island Humane Establishment, the purpose of which was to save lives and salvage cargo. During the tenure of the Humane Establishment, active from 1801 to 1958, some 222 recorded schooners, barques, brigs, brigantines, ships, terns, pinks, and steamers came to grief there. Numerous unknown wrecks occurred offshore, marked, if at all, by a bit of flotsam — perhaps a puncheon, broken spar, or corpse — washed up on the beach.

Through time, the Humane Establishment grew to nearly 50 persons, including staff and families. Main Station was the administrative centre where the superintendent resided and where a boat house, barns, blacksmith, and other shops as well as the Sailors' Home (for wreck survivors) were located. Three satellite lifesaving stations and several huts were strategically situated about the island. Lighthouses were constructed and manned at both the east and west ends. Beach patrols by horseback, observations from lookout towers, lifesaving drills, and heroic rescues facilitated (in the latter part of the 19th century) by lifeboat, rocket, whip-line, and breeches buoy were all part of the "surf-man's" duties. In addition to these tasks, the Establishment was expected to be all but self-sufficient, with only a few necessities imported by supply-steamer. As such, employees were also farmers, cowboys, fishermen, beach-combers, carpenters, and jacks-of-all trades.

Associated with the long years of the Humane Establishment are myriad stories and legends of courageous endeavour and adversity; wreckers, ghosts, and phantom ships; West Spit washing away with lighthouses toppling over; and, of course, the wild horses for which the island is renowned. These and other narratives have been well researched and chronicled by such authors as Bruce Armstrong, Lyall Campbell, Barbara Christie, James Farquhar, and George Patterson.

Back on mainland Nova Scotia, one fine autumn day we were talking with an elderly Blue Rocks fisherman about his memories of the terrible August hurricanes of 1927 and 1928, when six Lunenburg schooners and 138 local men were lost on Sable's shoals. Upon learning that we were photographing the island, he rather brusquely commented, "Why bother. There's noth'n out there but sand, seals, wild horses, and shipwrecks."

The old salty was right, of course, in a cursory sort of way. However, as we discovered while hiking amid Sable's tawny dunes, with the roar of the surf resounding from either shore, there is much more to this unique piece of Canadian wilderness than his simple words convey. As such, we have focussed our attention on the island's for-the-most-part unheralded natural beauty — an encapsulated world of sky, sea, sand, flora, and fauna, where the sights and smells of life and death are so readily apparent.

Although much has been written about Sable's human and natural history, very little has been done in a visual sense to answer the question, "What does Sable look like?" We hope that, through our annotated colour photographs and the accompanying historic images, the reader may get a fairly comprehensive view of this unusual island: one that, due to its inherent isolation, difficulty of access, and the necessity of restricted admittance, few people have the opportunity to experience firsthand.

The wooden figurehead of a sailing ship wrecked on Sable.

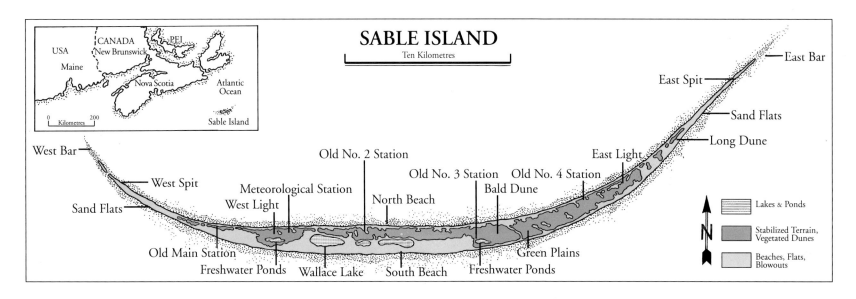

SABLE ISLAND

Ten Kilometres

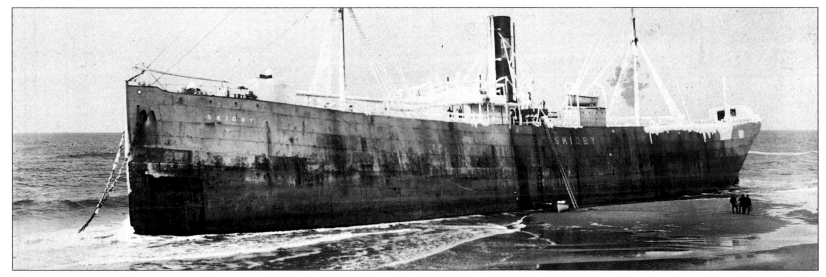

On January 31, 1905, in thick fog the *S.S. Skidby* grounded and cracked her hull on a submerged northwest sandbar off Sable Island. With the rising tide and strong westerly winds, she lifted and bumped over the shoals, only to drift down the island and strike once again almost on the dry beach.

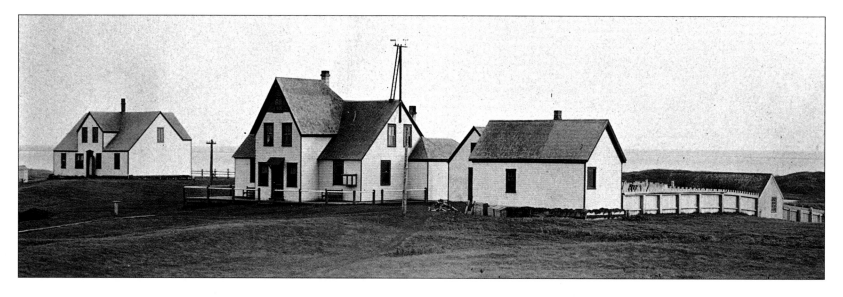

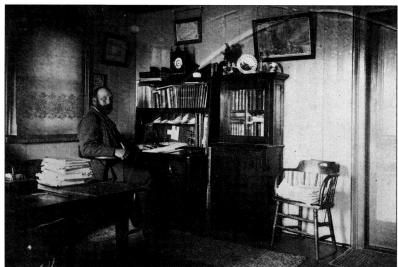

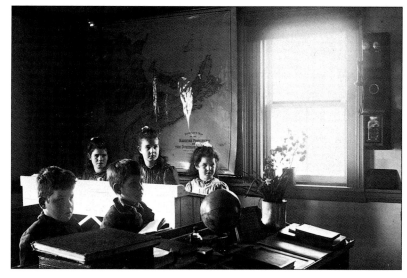

Upper: Main Station, 1899. Headquarters of the Humane Establishment.
Lower Left: R.J. Bouteillier, superintendent 1884-1912, at his writing desk.

Lower Right: When a tutor was available, the island children attended boarding school held at the old No. 2 Lifesaving Station, 1899.

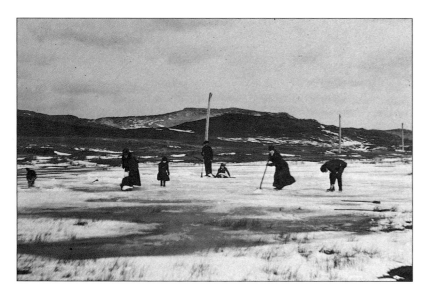

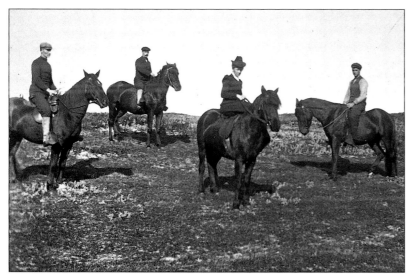

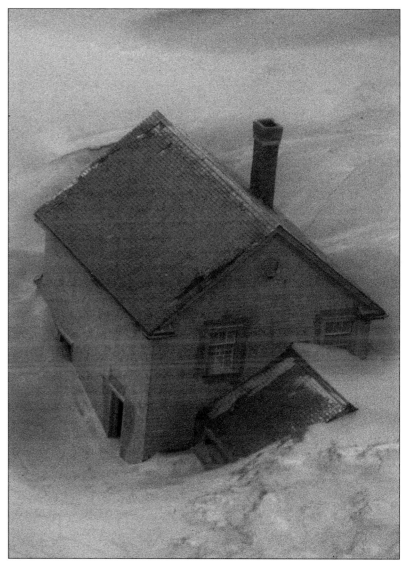

Upper: Skating on a pond by telephone line, which linked all stations in 1885.
Lower: Skilled photographer Trixie Bouteillier *side-saddle* with family, 1899.

East Light, 1983. The lighthouse keeper's home long abandoned to wind and sand. A similar fate befell many original and subsequent buildings.

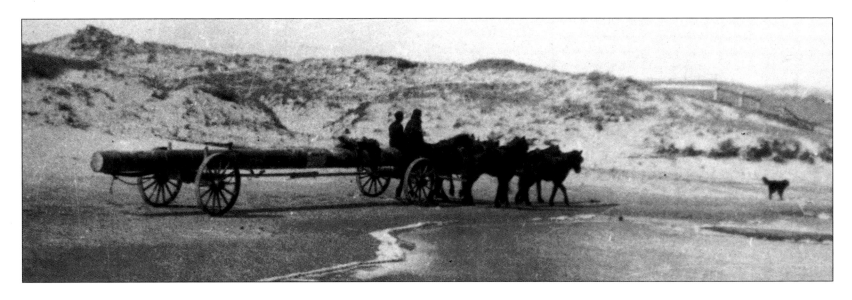

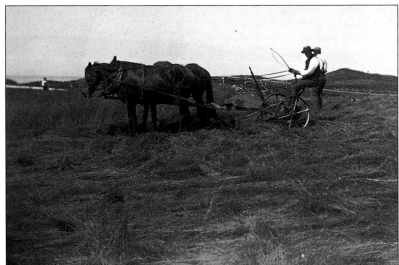

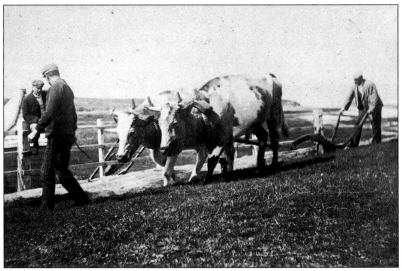

Upper: Salvaging a spar from a shipwreck to be hewn square and whip-sawn into boards. Ships' timbers and driftwood were also gathered for fuel.

Lower: The Humane Establishment was expected to feed itself. Cattle, pigs, and poultry were raised. *Left:* Mowing hay. *Right:* Oxen ploughing fields.

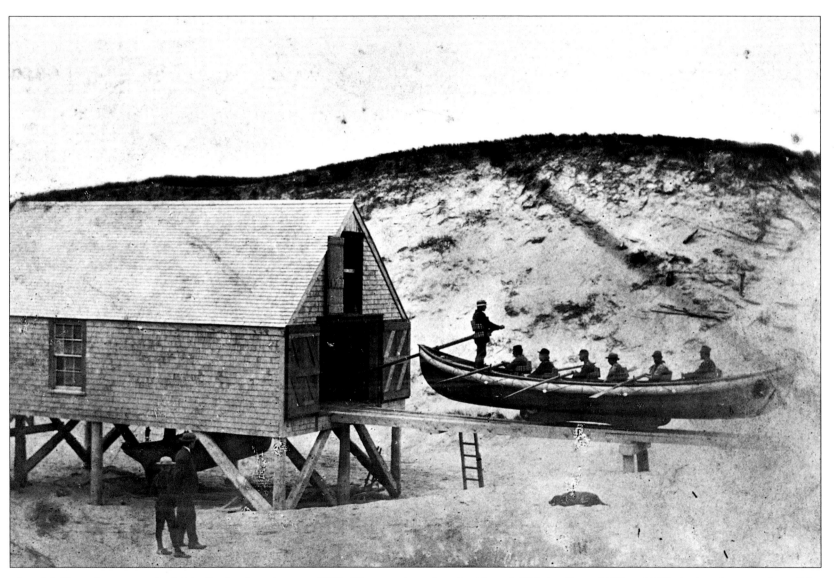

Land drill on the ways at the Main Station boat house c.1898. The crew is equipped with cork lifebelts. From 1801 to 1958, during the operation of the Humane Establishment, some 222 shipwrecks occurred. The lifesaving crews were extremely successful in rescuing survivors and salvaging cargos.

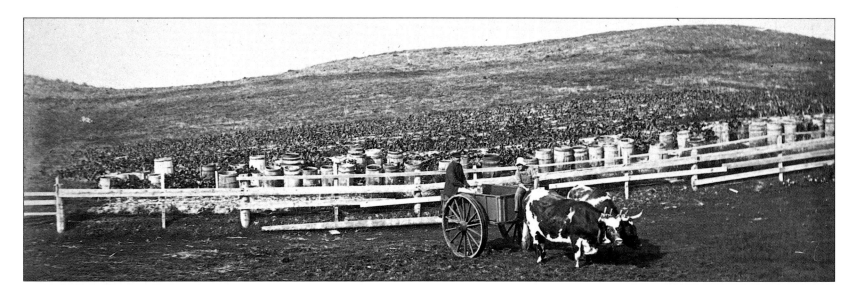

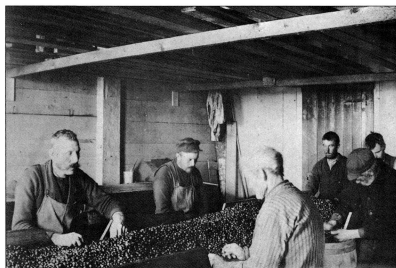

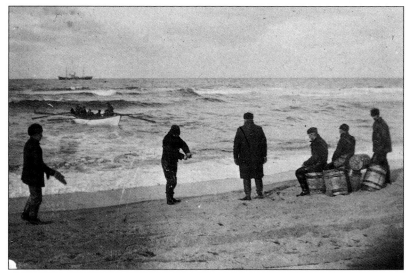

Upper: Flour barrels packed with wild cranberries picked by the Islanders. The government sold the berries on the mainland for $5.00 a barrel, 1900.

Left: Staff and boys clean and sort the large and lovely cranberries, 1895.
Right: Shipping berries by surfboat to a steamer anchored a mile offshore.

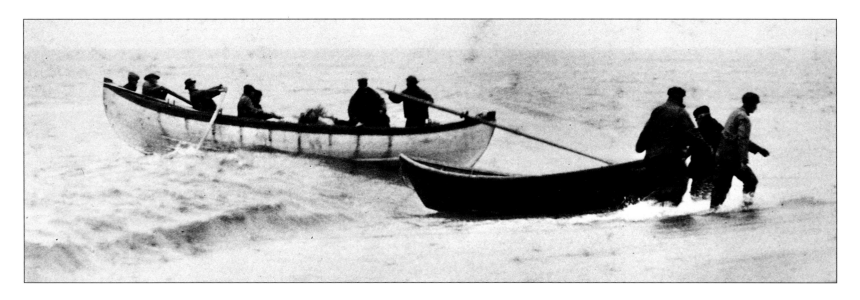

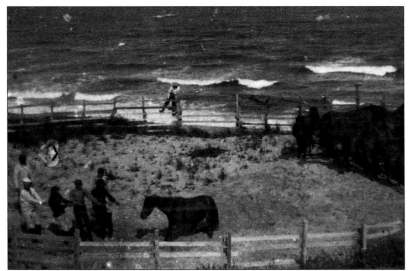

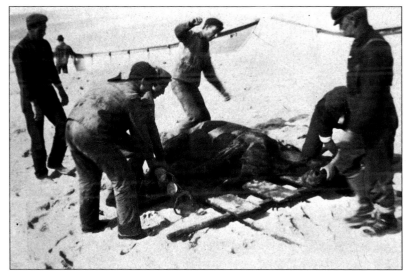

Upper: Lifeboats, and more commonly surfboats, transported shipwreck survivors, salvage, berries, horses, and dispatches to waiting steamers.

Left: Impounded wild horses destined for government auction in Halifax.
Right: Immobilizing a wild horse prior to shipment off island, 1900.

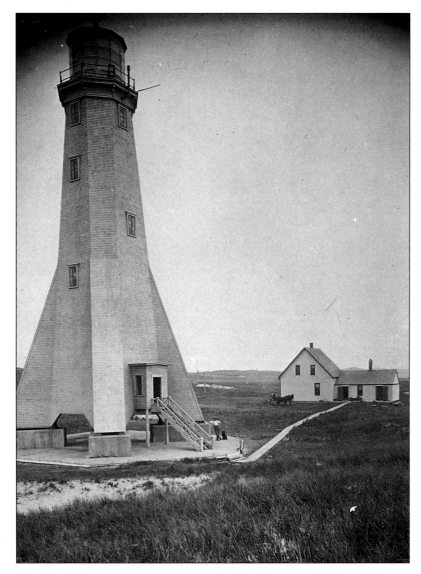

The "new" ferro-concrete, 30-metre tall West Light was built in 1888 atop a large dune, well inland. It was toppled by the advancing seas in 1916.

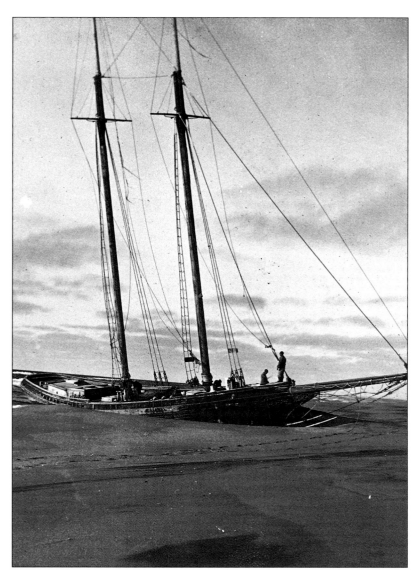

Schooner *Charles H. Taylor* wrecked April 17, 1897. Fourteen men made shore in dories; four were taken off with the whip-line and breeches buoy.

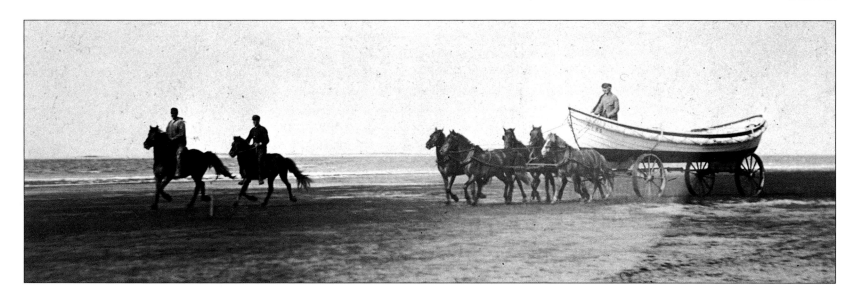

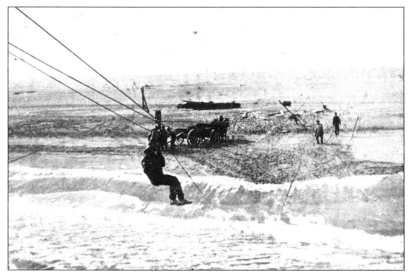

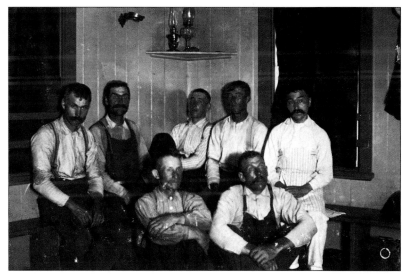

Upper: Five gelded Sable Island stallions haul the lifeboat loaded with rocket apparatus, whip-line, and lifebelts over the soft sand to a wreck site.

Left: Deliverance via breeches buoy: canvas pants sewn to a life preserver.
Right: Survivors residing in the Sailors' Home await passage to Halifax.

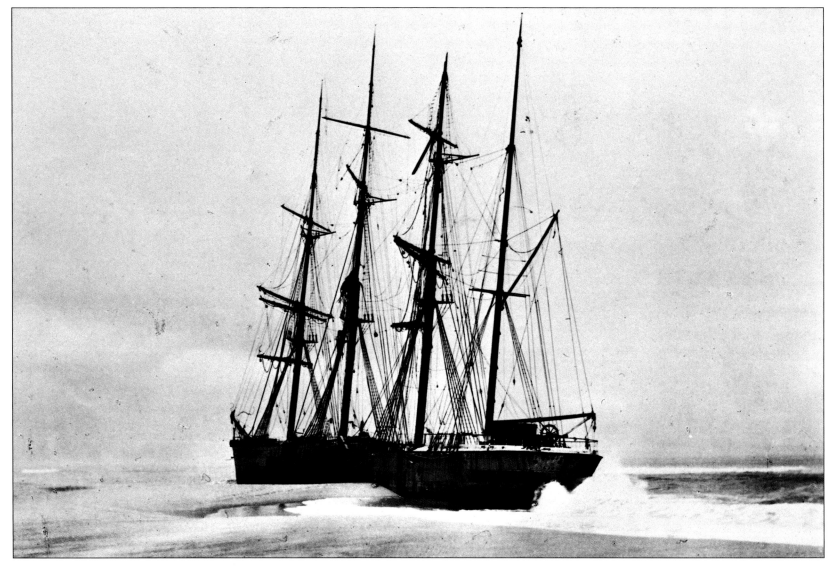

On April 17, 1898, the stately four-masted British barque *Crofton Hall* stranded in dense fog off East Spit. Her hull was broken in two amidships. Discovered by Islanders on routine horse patrol, all 33 hands were subsequently saved, 12 people by rocket apparatus and breeches buoy.

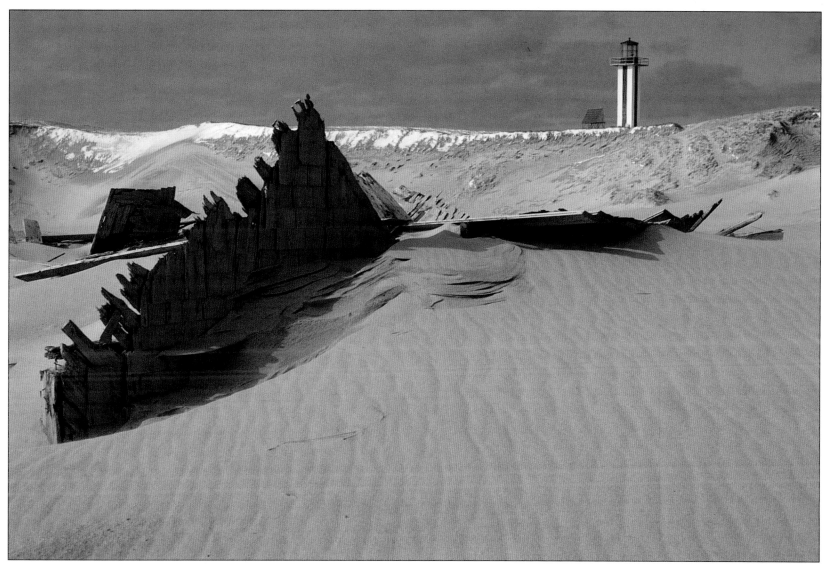

The fully automated, solar-powered East Light stands sentinel beyond the ruins of the former lightkeeper's home which through time *(see page 9)* was buried in its entirety by an encroaching dune, 1993. Once sand claimed the lower floor, staff lived in the dwelling's upper storey for several years.

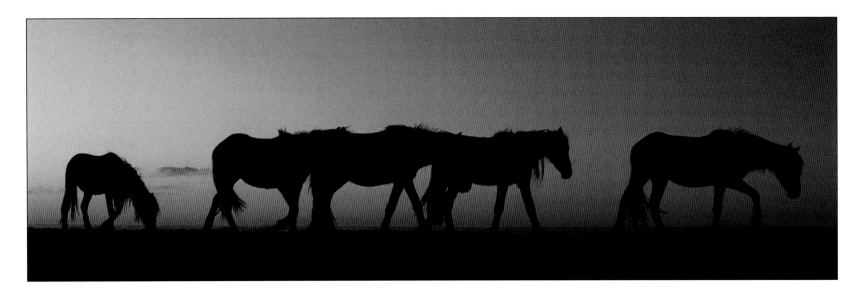

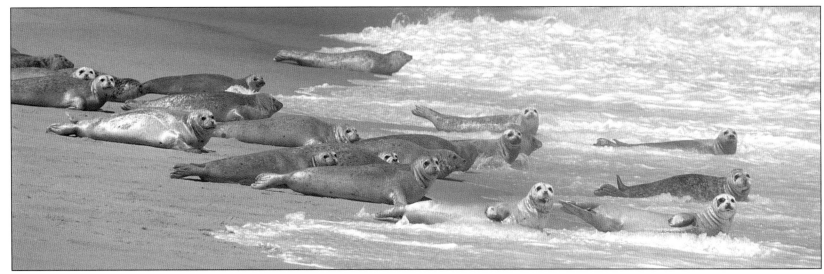

Upper: Evening by the seashore. For years the wild Sable Island horses were incorrectly referred to as ponies due to their size, 14 hands at the withers.

Lower: A small herd of Harbour seals sunning at the surf-line, North Beach. On warm, summer days thousands of seals relax on Sable beaches.

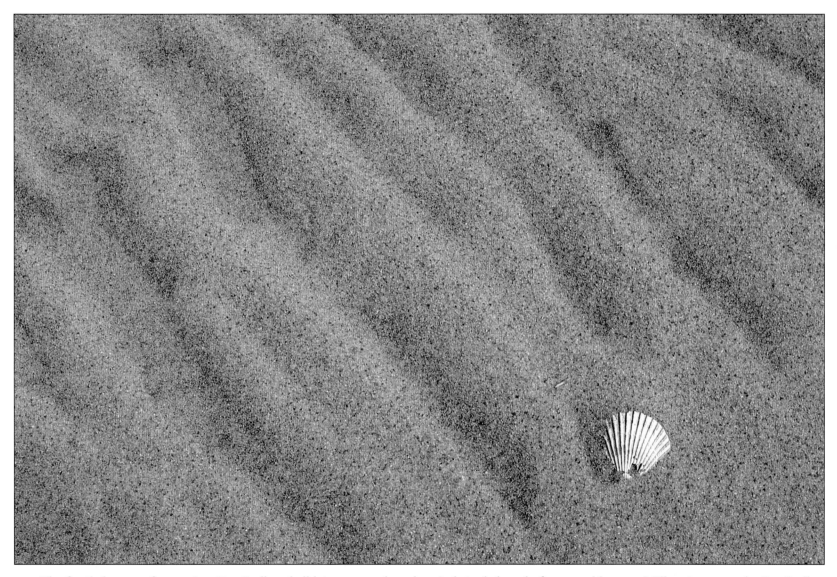

The fragile beauty of an ancient Bay Scallop shell lying exposed on the wind-rippled sand of a recent blowout. Millenniums ago the Bay Scallop thrived in Sable's then warm, shallow waters and lagoons, only to die out entirely about 2,000 years ago when the ocean temperature cooled.

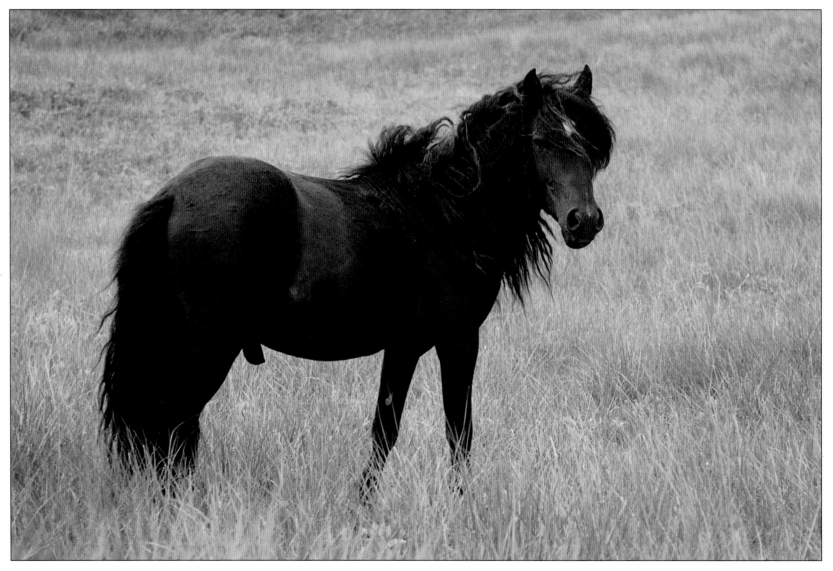

A handsome herd stallion with his muscular, highly arched neck stands in a lush mid-summer pasture of American Beach-grass. Folklore misleadingly has it that Sable's hardy horses descended from those that managed to swim ashore from the unknown wrecks of Portugese, Spanish, or French ships.

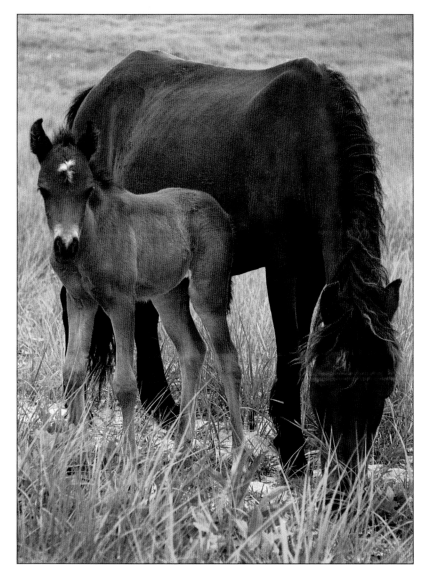

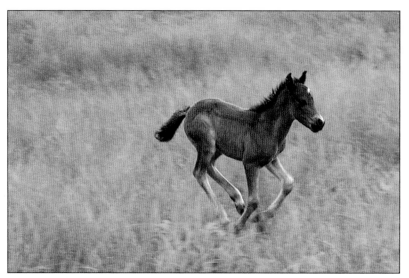

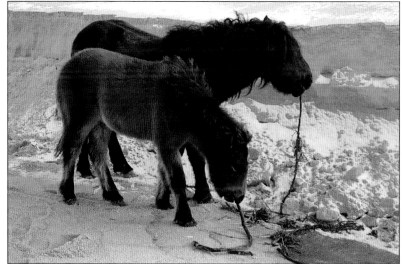

A mare and long-legged foal. The colt *(above and upper right)* carries the same white star on its forehead as its sire *(stallion facing image)*.

Lower Right: The same colt six months later, taller and now woolly in its winter coat, pauses to eat nutritious kelp washed up by the storms.

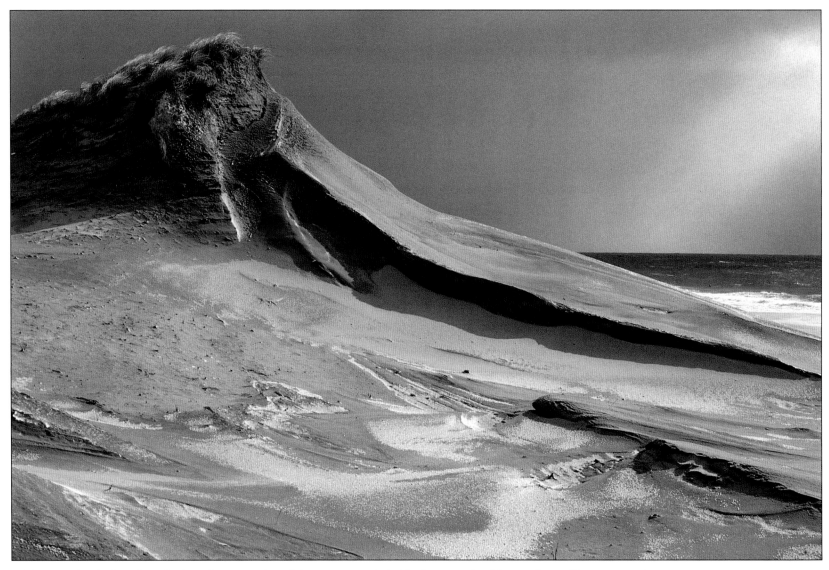

Sable is an island of sand perched on the outer edge of the Continental Shelf. The warmth of the nearby Gulf Stream moderates winter temperatures, which normally hover between +5°C and -5°C. Blinding winter gales with snow, sleet, and rain are common. On the few days of calm, fog can be dense.

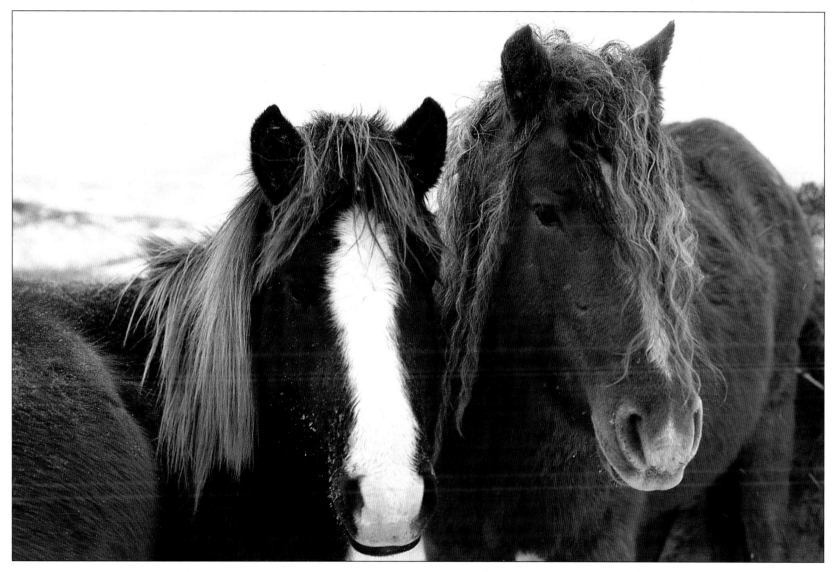

Despite the short-term presence of a few domestic stallions brought from the mainland to serve the Humane Establishment, Sable Island horses have bred by a process of natural selection for nearly 250 years. They are a gene pool, one of the few living equine populations untampered by man's selective breeding.

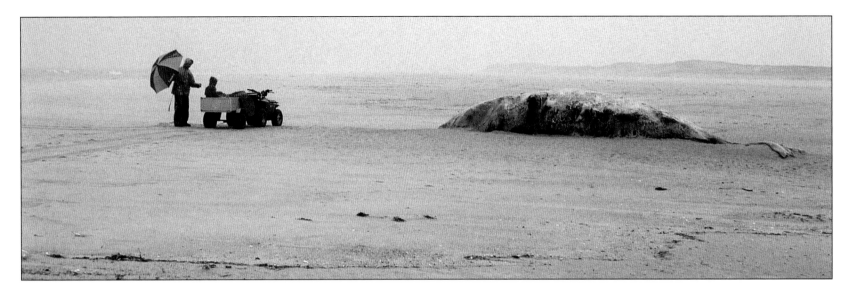

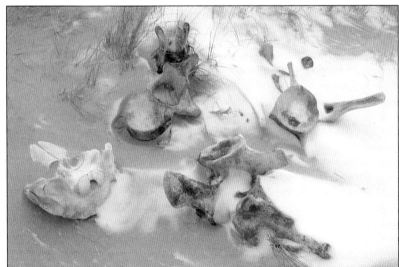

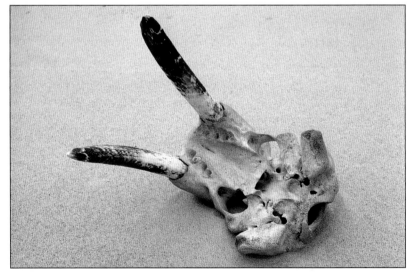

Upper: The putrid carcass of a Sperm whale washed up on South Beach.
Lower Left: Sun-bleached whale bones exposed on the side of a dune.

Lower Right: An old walrus skull and tusks. Thousands of walrus bred on Sable until hunted to extinction for ivory, hide, and oil in the early 1600s.

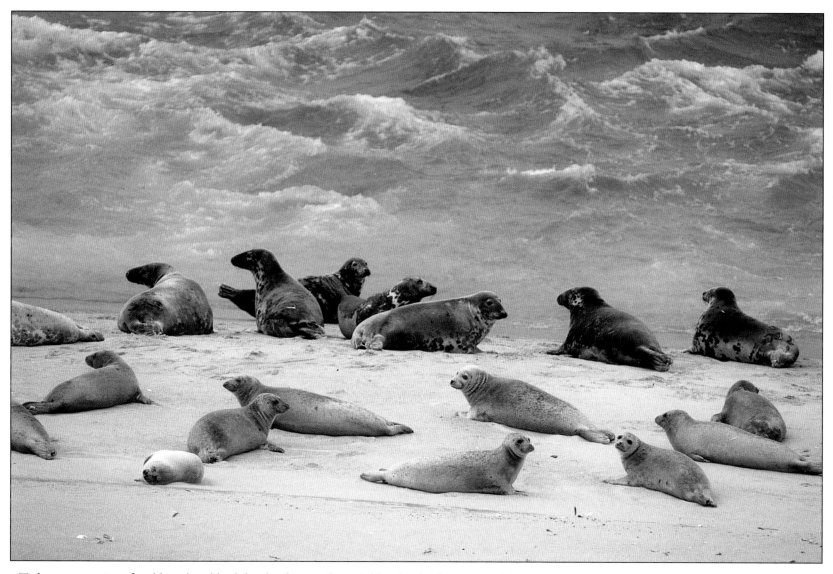

Today, two species of seal breed and bask by the thousands on Sable Island. The Grey seal, larger and darker *(nearer the ocean)*, gives birth and breeds during the biting chill of January. Harbour seals *(foreground)*, are lighter in colour and smaller in size. They rear their young and mate in May.

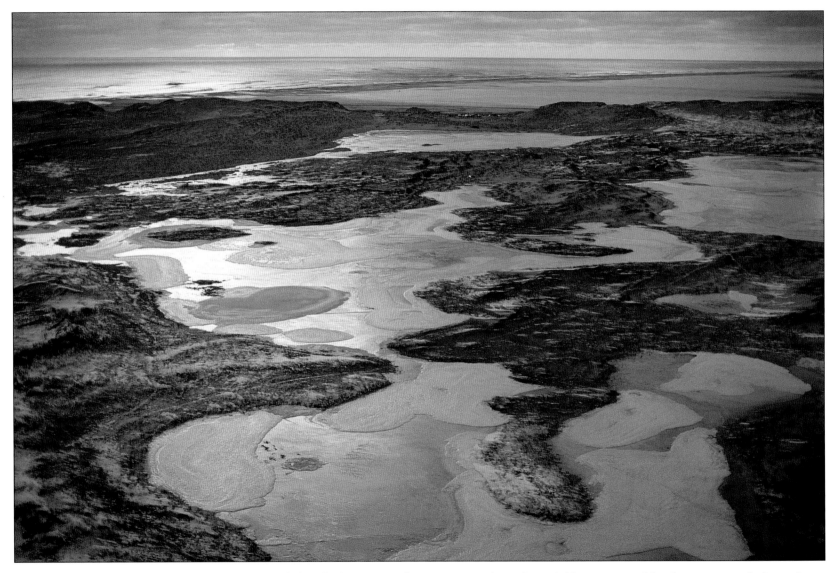

The rosy light of a setting winter sun illuminates frozen freshwater ponds near West Light. Life on Sable is sustained by the presence of a lens of fresh water that underlies the surface of the sand. This lens, located only slightly above sea level, is solely fed by rain water and melting snow.

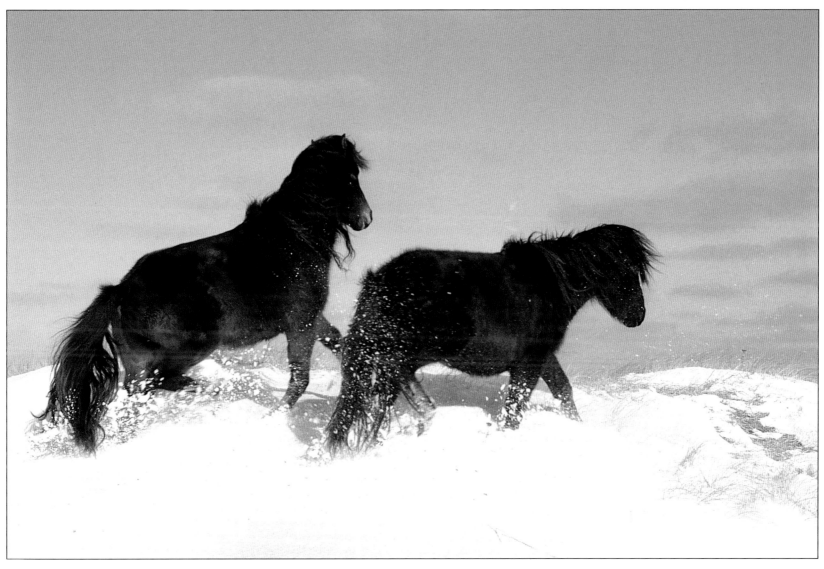

Horses crest a snow-covered dune. With their small stature (139 cm to the withers; stallions weighing up to 405 kg, mares up to 360 kg when not with foal), convex "Roman" noses, low-set tails, and muscular shoulders, many of Sable's wild horses display characteristics of the North African Barb horse.

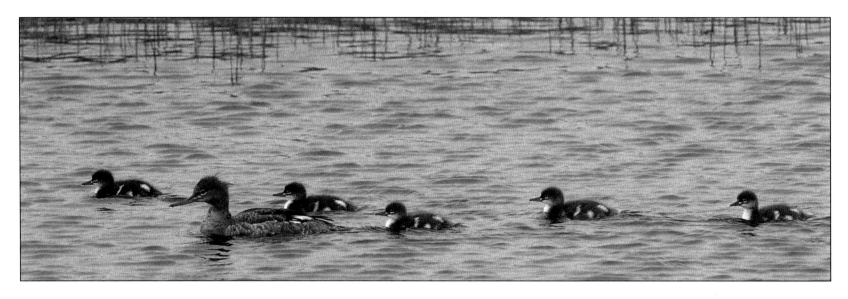

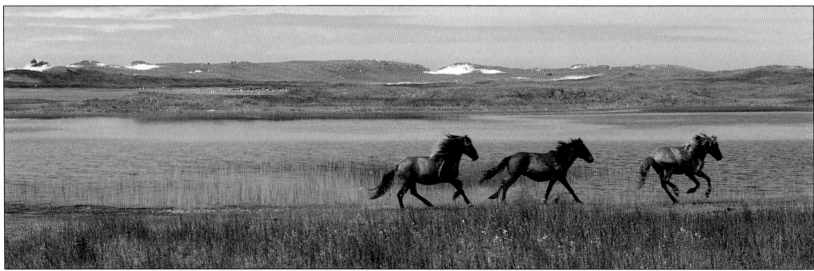

Upper: A Red-breasted Merganser and her brood, in formation, practise swimming and diving in a shallow freshwater pond near the Meteorological Station.
Lower: A small gang of three young bachelor stallions, as yet too immature to have mares and herds of their own, gallops along the shore of a pond.

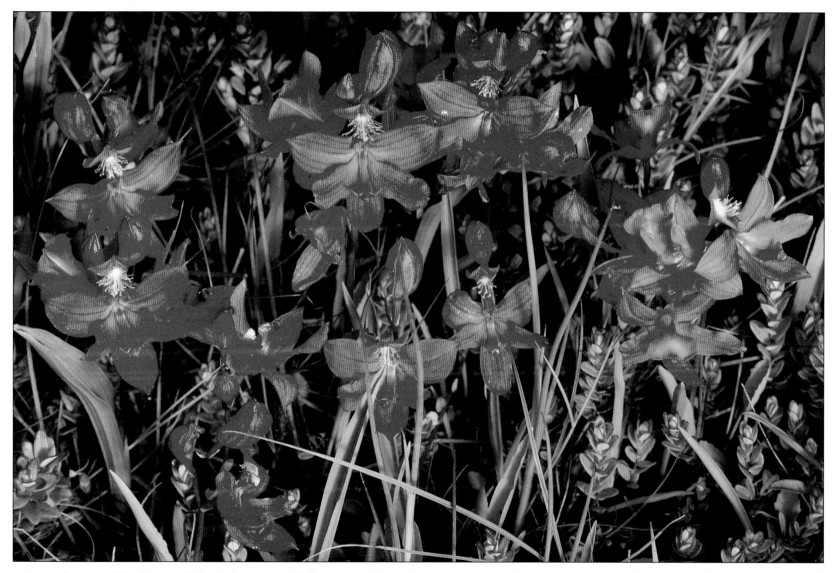

Positively tropical-looking orchids, *Calopogon pulchellus*, with brilliant blossoms and grass like leaves, grow in profusion on Sable Island. The warmth of July sees dense pink carpets of these exquisite flowers enlivening the moist depressions between the stable, vegetated inland sand dunes.

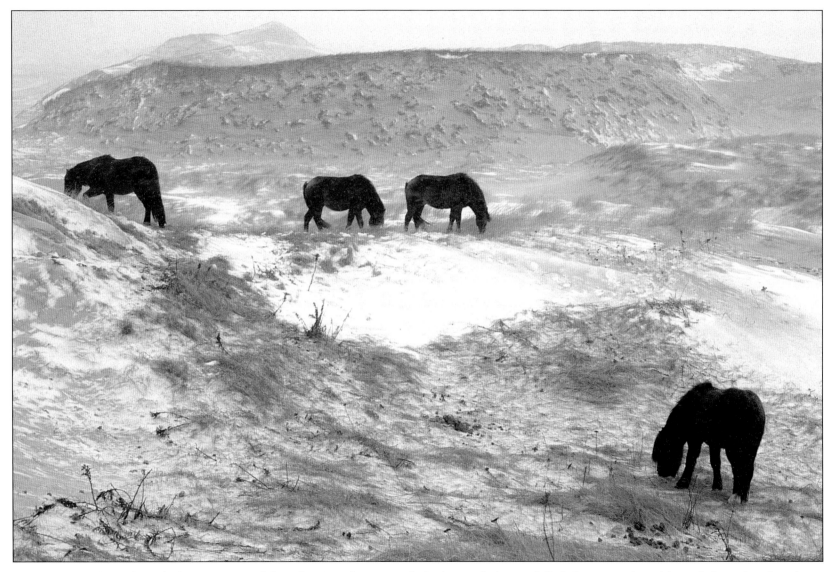

When winter gales strike with driving snow and sleet, freezing salt spray, and stinging sand, the tough little horses survive without shelter other than that to be found in the lee of dunes. At other times the horses forage most of the day, gleaning what calories they can from the withered, brown Beach Grass.

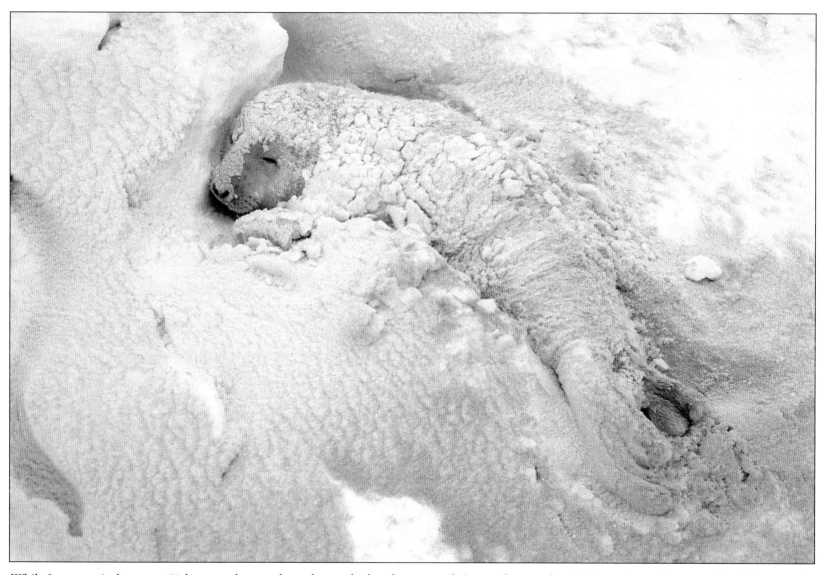

While January winds rage at 50 knots and more along the nearby beach, a weaned Grey seal pup, white in its natal coat, has a comfortable snooze in a snow bank on the shielded side of a sand dune. It is not unusual to observe plump pups almost completely drifted over with snow and sand.

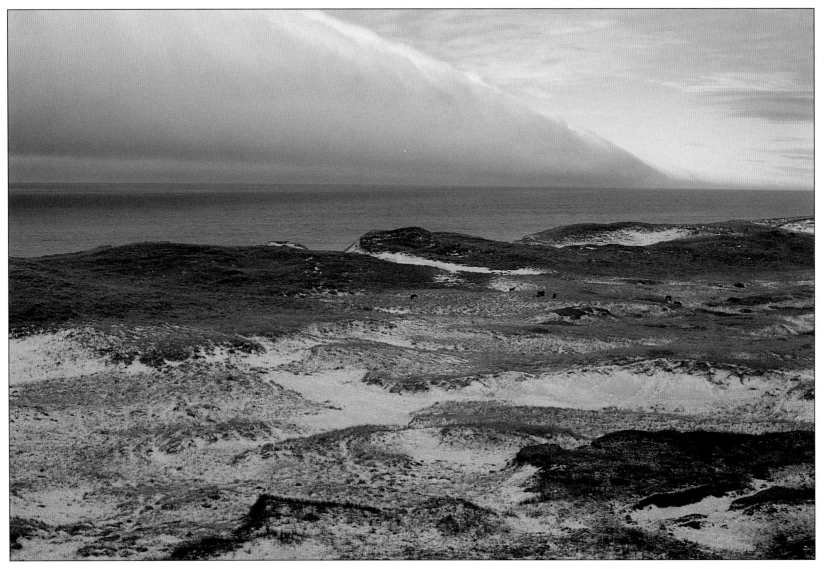

An ominous front sweeps in from the Atlantic and will, within minutes, blot out the sun, blanketing Sable with thick fog, which can last for days before dissipating. Sable experiences an average of 125 foggy days a year, one cause of the numerous shipwrecks that occurred before the invention of radar.

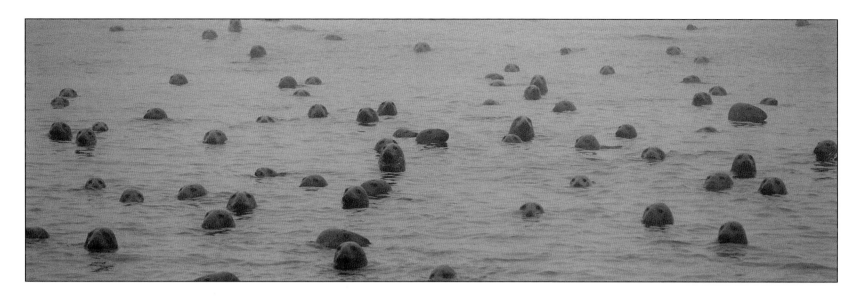

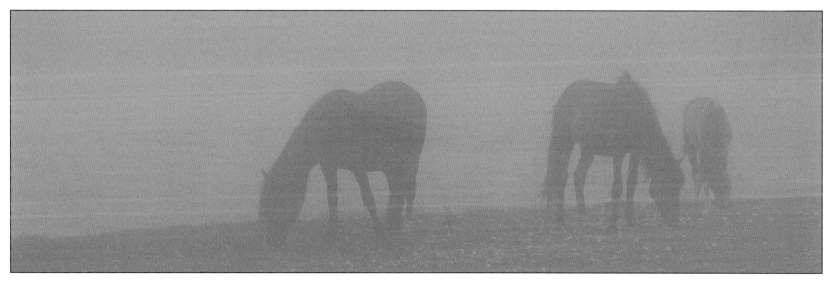

In summer, warm air rising from the Gulf Stream mixes with cool air associated with the Labrador Current flowing from the north. The result is frequent fog. *Upper:* From the safety of the ocean, Grey seals curiously watch the happenings on shore. *Lower:* Horses feeding in the mist at the edge of a pond.

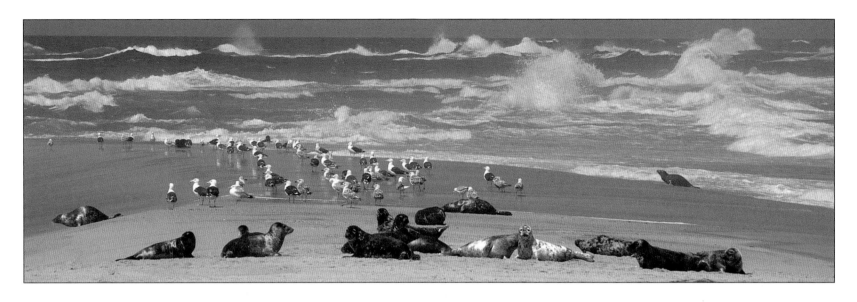

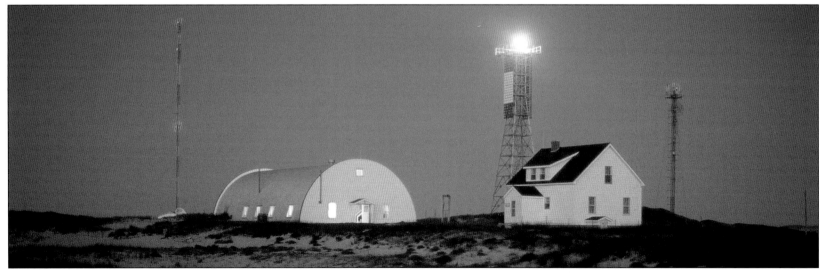

Upper: Even on a calm day conflicting currents and treacherous shallows cause seas to explode over the tip of West Spit and the 12-km long wet bar beyond.
Lower: West Light casts its beam across the night sky. The Coast Guard quonset hut is outfitted to provide emergency shelter for victims of disaster at sea.

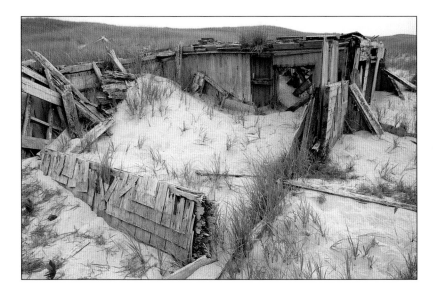

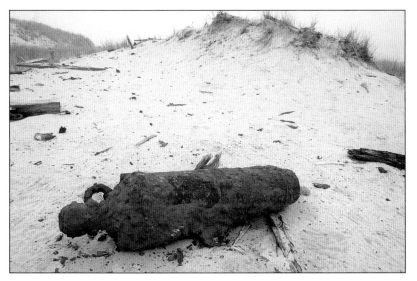

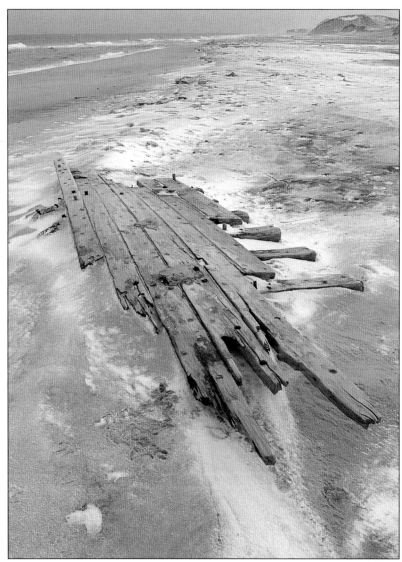

Upper: Remnants of Main Station, centre of the old Humane Establishment.
Lower: Carronade, a 1700s-vintage carriage gun from an unknown wreck.

Winter storms temporarily expose a poignant reminder of past disaster —
shattered ribs and dowel-pinned planks, part of the hull of a sailing ship.

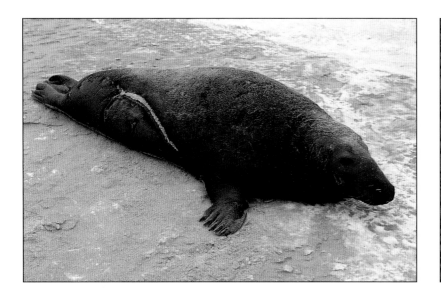

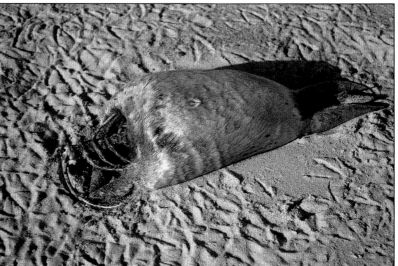

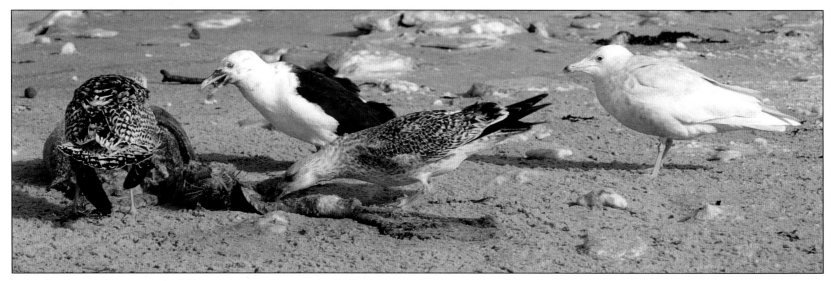

Left: A male Grey seal exhibits a pink scar, the outline of a large shark's bite.
Right: Harbour seal pups, such as this decapitated one, fall easy prey to sharks.

Lower: An adult and two immature Great Black-backed Gulls and a pale second-year Glaucous Gull pick the carcass of a Grey seal pup.

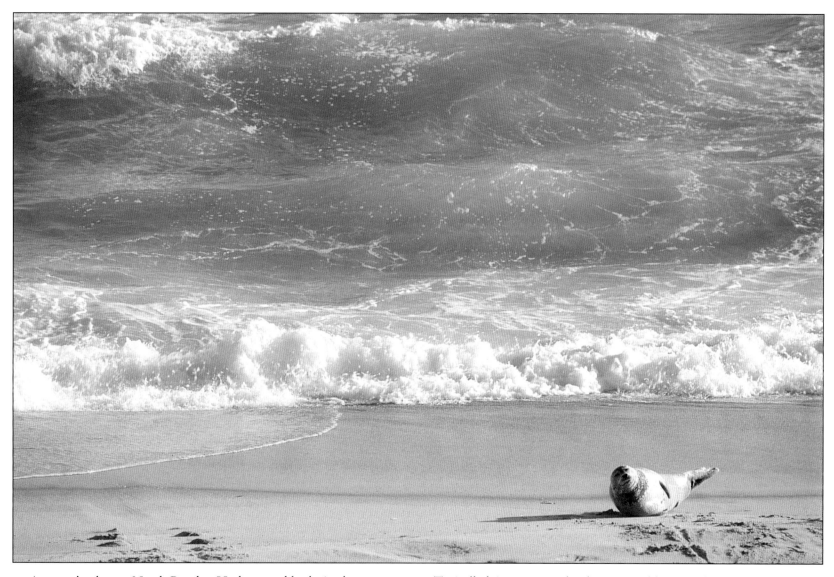

At water's edge on North Beach a Harbour seal basks in the summer sun. Typically lying to one side, the mammal keeps its head and rear flippers raised out of reach of the surging surf. Harbour seals are the smallest seal in the Maritimes and can grow to 170 cm in length and 100 kg in weight.

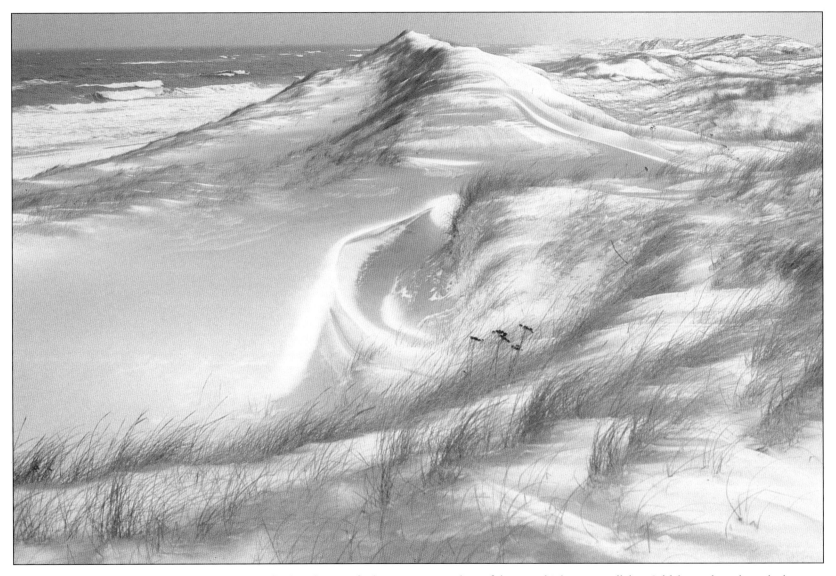

Beyond the island's over-washed spits and wide, flat beaches rise fairly continuous ridges of dunes, which run parallel to Sable's north and south shores. The presence of vegetation and the tenacity of root systems help stabilize these magnificent wind-sculpted sand dunes and retard their migration.

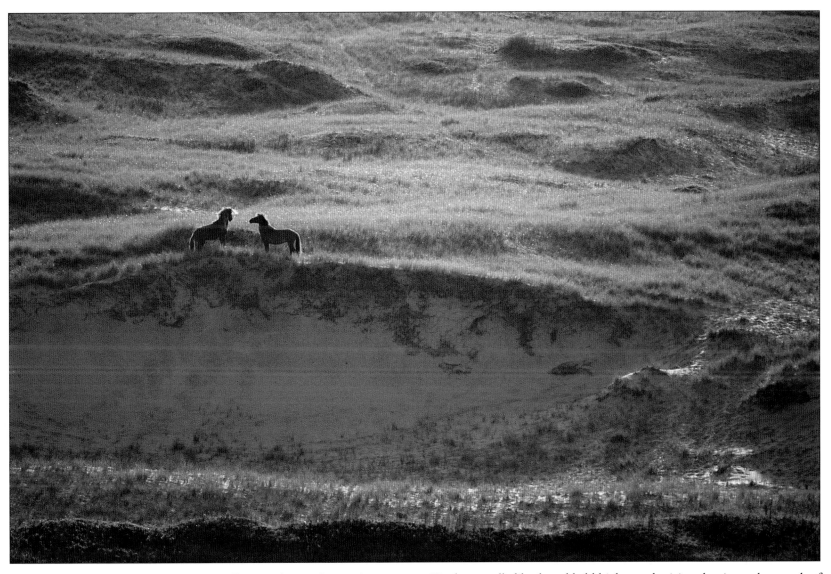

In the rich light of early morning two stallions exchange threatening gestures. Heads are pulled back and held high, emphasizing the size and strength of their necks and shoulders. Partially cocked tails, frequent head-tossing, some neck-wrestling and leg-stamping were the extent of this brief altercation.

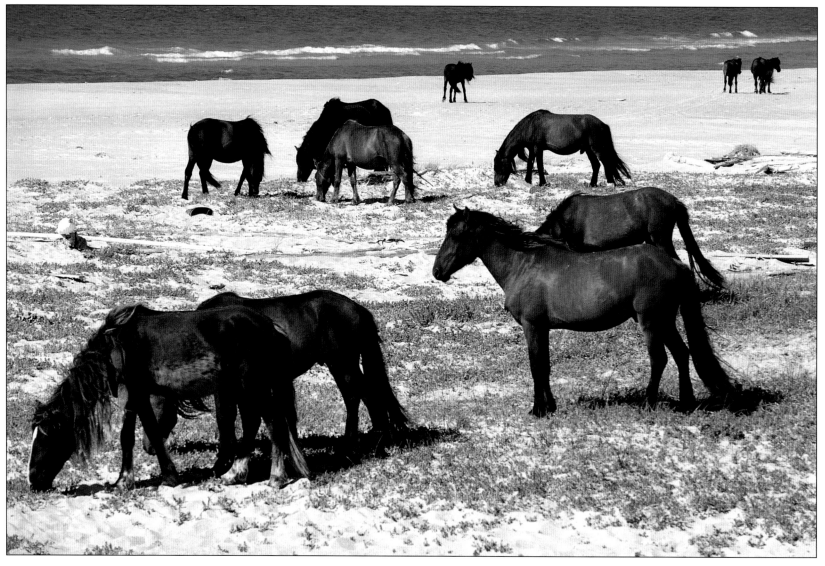

Although cattle and pigs were taken to Sable in the 1500s by the Portuguese, all animals were removed and slaughtered by Acadians and New Englanders a century later. In 1671 Nicholas Deny and in 1738 Rev. Le Mercier reported that there were no animals on the island. From where then did the horses come?

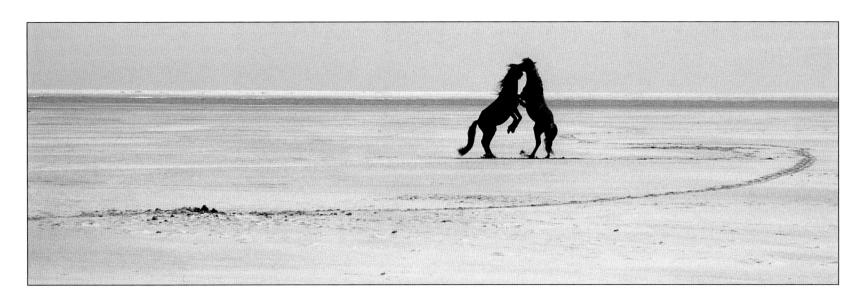

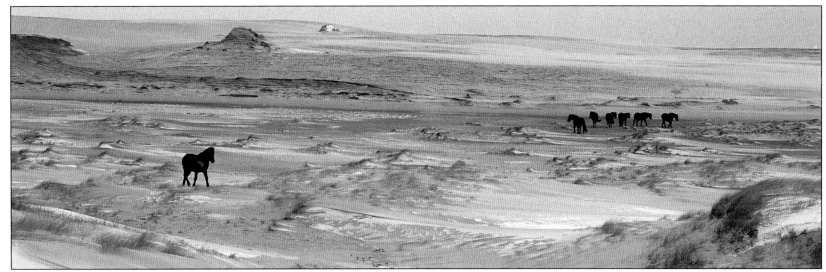

Upper: A play fight, "boxing," between two immature males prepares bachelors for more meaningful encounters with herd stallions when they get older.
Lower: A raider approaches a breeding herd with the intention of stealing a mare. The herd stallion trailing his harem keeps a wary eye on the intruder.

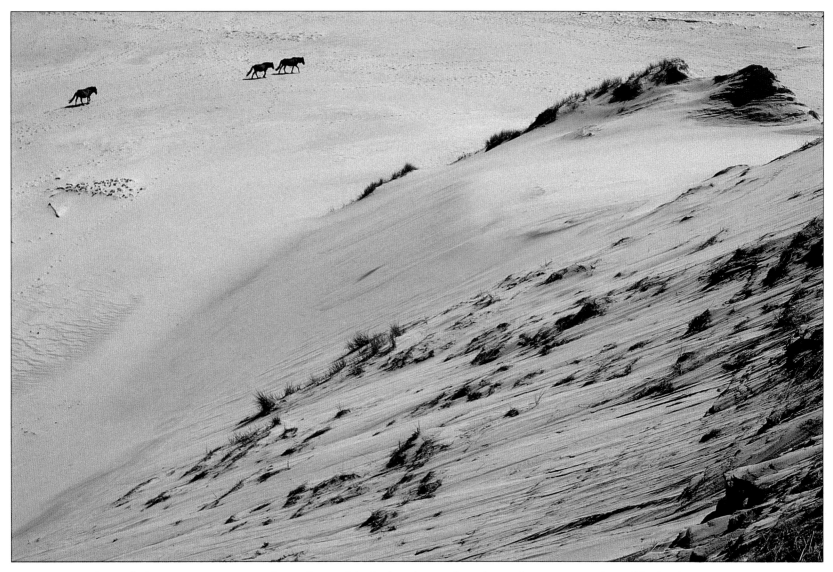

Near East Spit beneath the sweeping 25 metre slope of one of the higher dunes, three distant horses cross a desert like landscape. Contrary to this illusion, Sable is no arid desert. Moisture sustains plants, which bind the sand, thereby allowing the dunes to grow both in height and breadth.

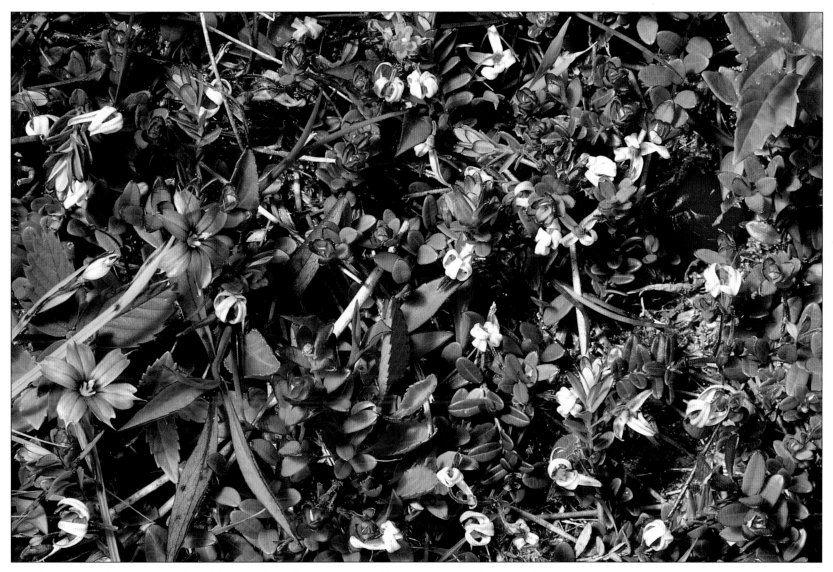

An abundance of soft pink cranberry blossoms foretells of bounteous fall fruit to come. The Large Cranberry, *Vaccinium macrocarpon*, is common on Sable, growing in the shallow, peaty soil of the sheltered wetlands that exist in many of the dune hollows. The delicate blue flowers are Blue-eyed Grass.

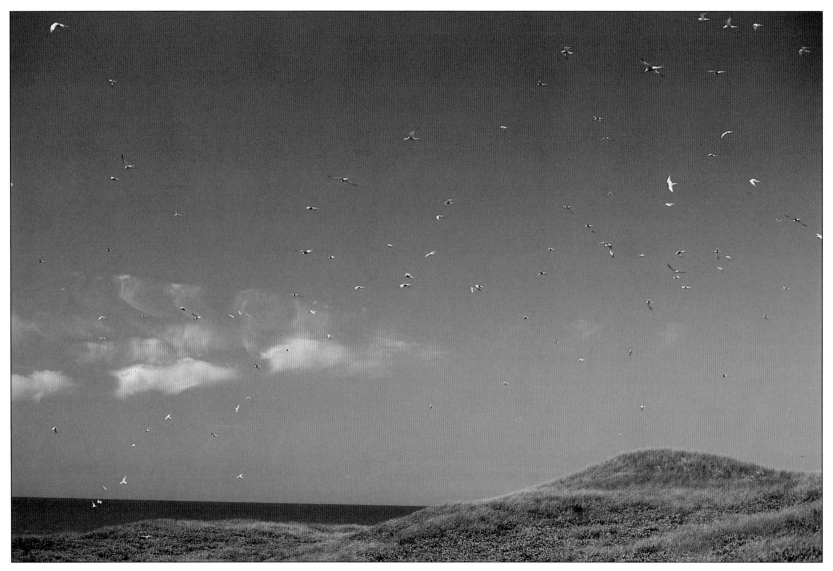

In a blue summer sky terns soar above their nesting grounds. Terns will fly well out of their way to ward off wandering horses from the nests, where eggs and young could easily be trampled. The birds will hover and then, with clamorous calls, swiftly dive to swoop just by the horses' heads.

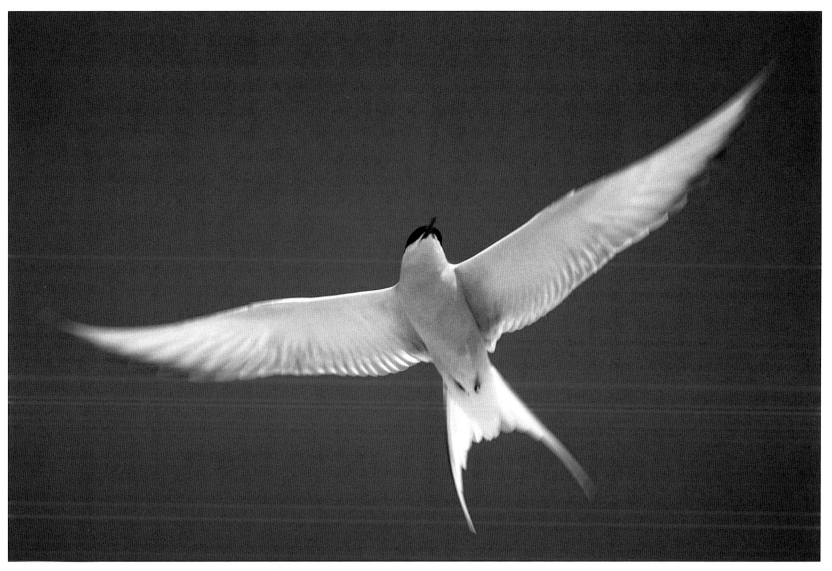

An Arctic Tern, with its identifying pure red bill, hovers overhead. An agitated bird may drop a "bomb" of fishy excrement on the unwary. Arctic, Common, and the rare Roseate terns all nest on Sable. During the 1800s, Islanders supplemented their diet with tern eggs collected by the bucketful.

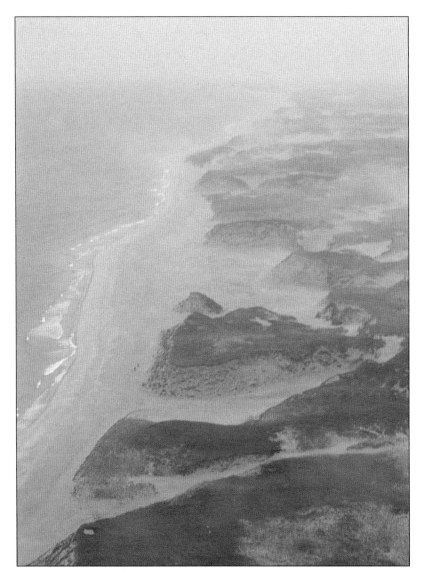

An aerial view eastward along North Beach shows coastal dunes incised by washouts and blowouts, which serve to further funnel wind and wave.

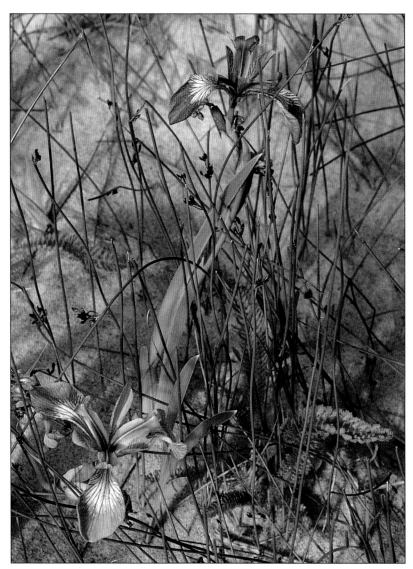

Less than half the island has plant cover. Inland, the undulating surface is generally vegetated with a variety of flora, including the Blue Flag Iris.

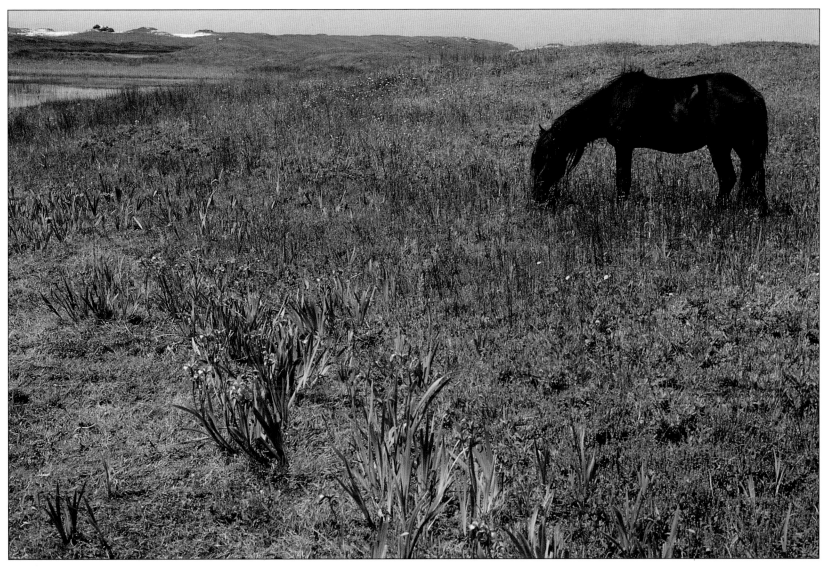

Many Sable horses exhibit characteristics of the North African Barb, a breed that originated in Morocco, Algeria, and Libya and came to Europe with invading 8th-century Moors. Europeans brought horses of mixed blood lines to North America, where native horses had died out about 8,000 years ago.

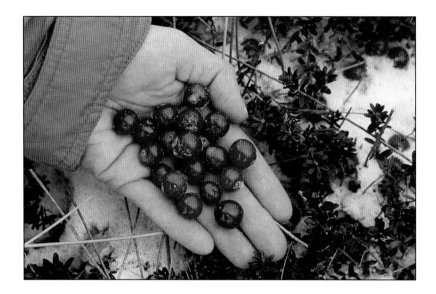

Upper: Up to 400 barrels of wild cranberries were once harvested every year.
Lower: An old barrel, blown against a fence, shelters Wild Rose and grasses.

A motionless Herring Gull chick, eye to the camera, hides camouflaged
beneath woody roots of heath plants exposed in a small localized blowout.

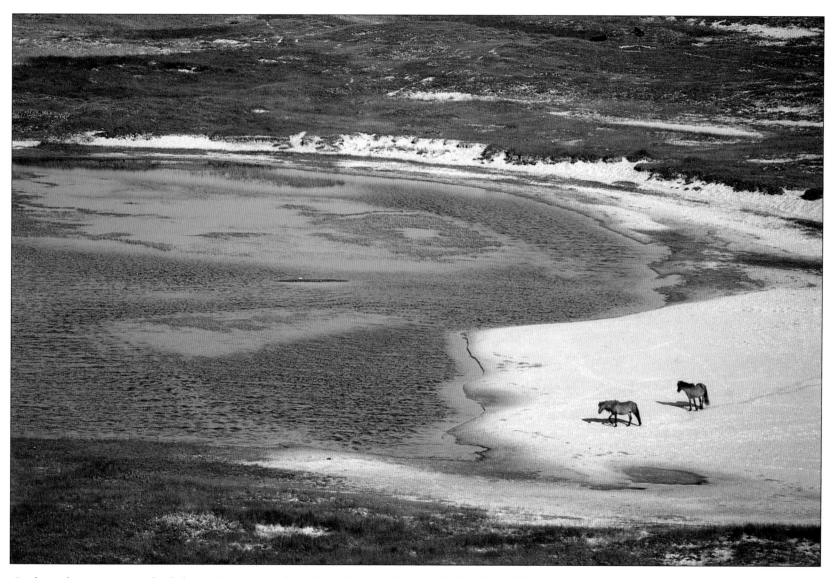

In the early morning two bachelors arrive at a pond to drink. Young males leave the family herd between one and four years of age to join bachelor gangs. As they get older and sexually mature, the bachelors spend much time harassing herd stallions, trying to steal mares and form family herds of their own.

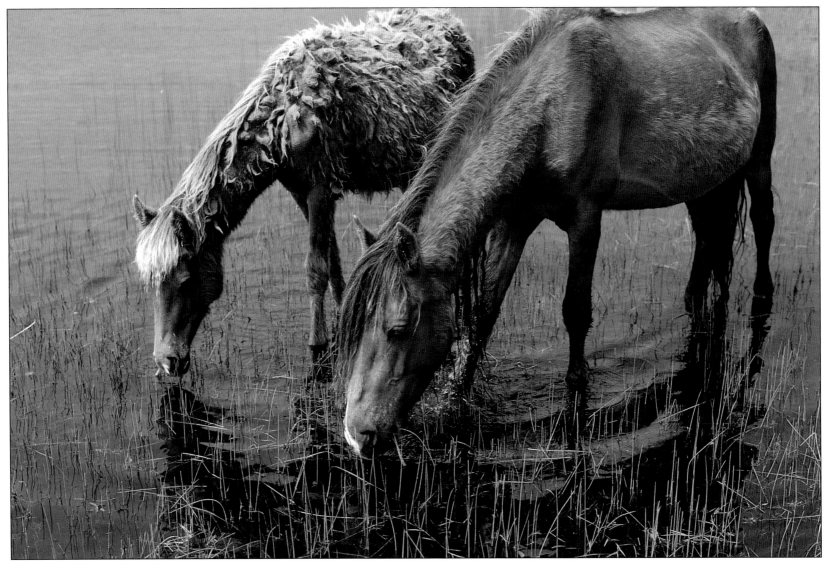

A pregnant mare and her moulting yearling feed on rushes in a pond. As readily accessible fresh water is limited, the territories claimed by the island's 40 to 50 family herds overlap at the waterholes. Herd stallions will co-ordinate the movements of their families to minimize contact and conflict with others.

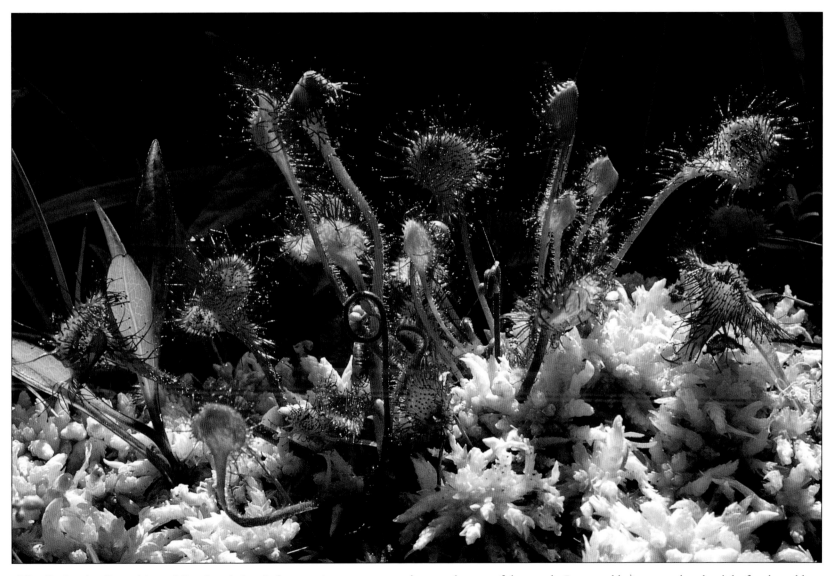

The diminutive Round-leaved Sundew thrives in boggy, nitrogen-poor earth around many of the ponds. Long, red hairs cover the plant's leaf pads and lure insects. Sticky, glistening drops of glandular secretions at the hair tips trap and digest insects, releasing protein and minerals to be absorbed by the plant.

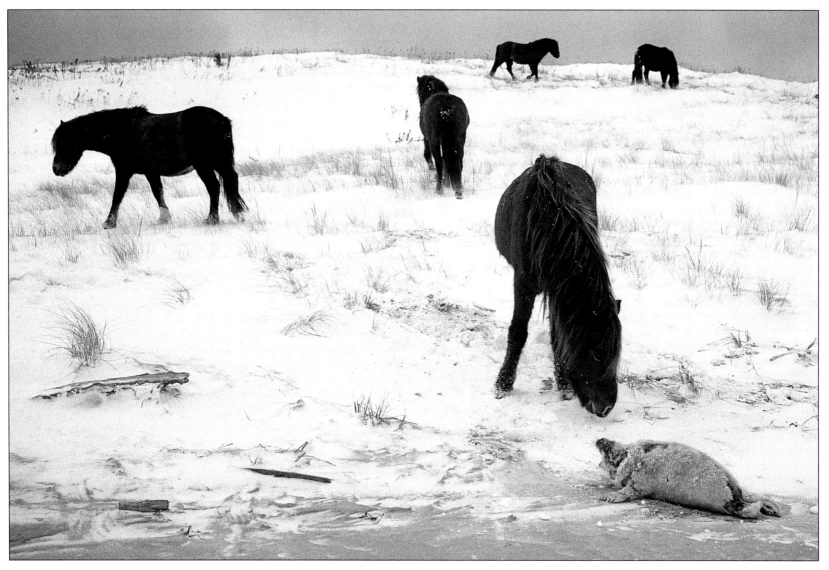

A nose-to-nose encounter of a horse and a growling, young Grey seal. Horses seem curious about the little seals that wander all over the island and into the horses' territories. Pups appear ready to defend themselves against all odds, or to beat a hasty retreat when the opportunity presents itself.

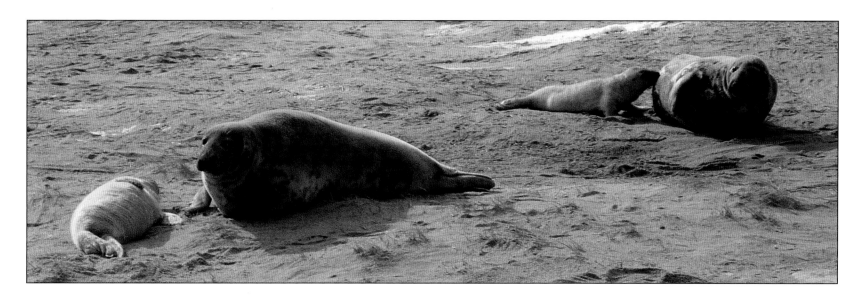

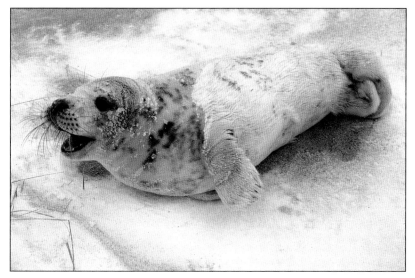

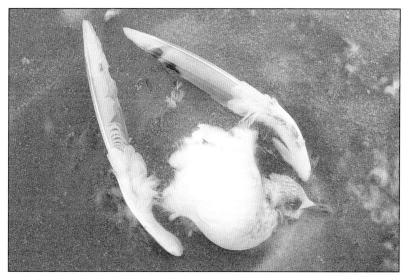

Upper: From a birth weight of about 16 kg, young Grey seals fatten on their mothers' rich milk, gaining an average of 42 kg in three weeks of nursing.

Lower Left: Female Grey seal pup with moult progressing from head to tail.
Lower Right: A Herring Gull, its neck likely broken by a protective cow seal.

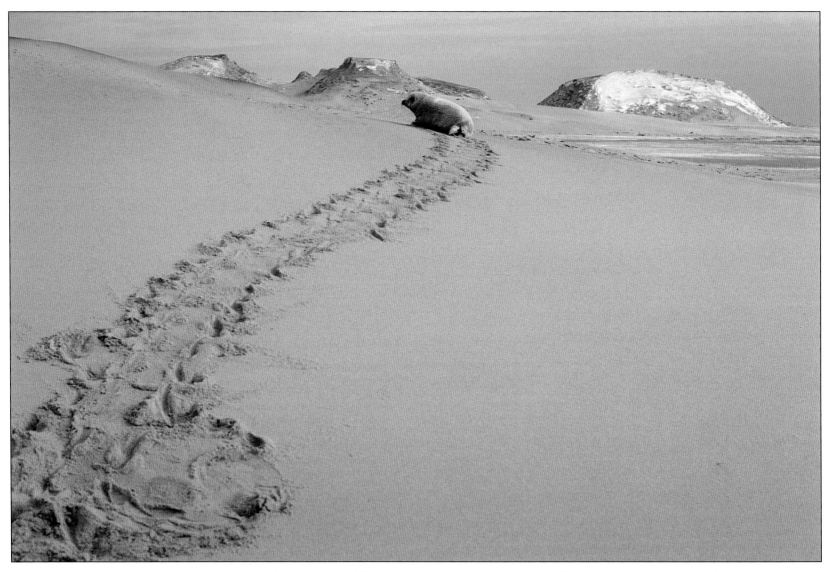

Weaned Grey seal pups wander rather aimlessly about the island for several weeks and are found in unlikely places. After their natal hair has moulted and they have slimmed down through lack of eating to become less buoyant, the pups feel hunger and take to the sea where they feed on sand lance.

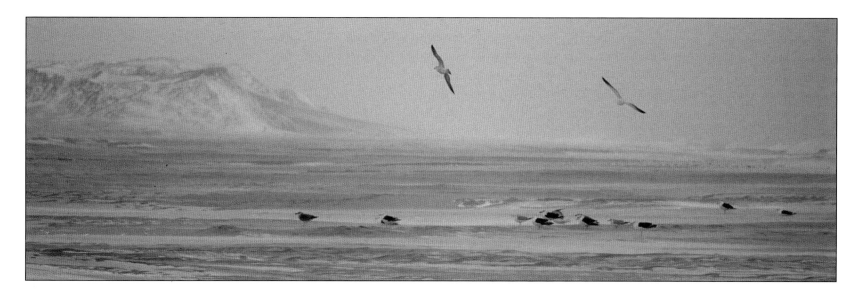

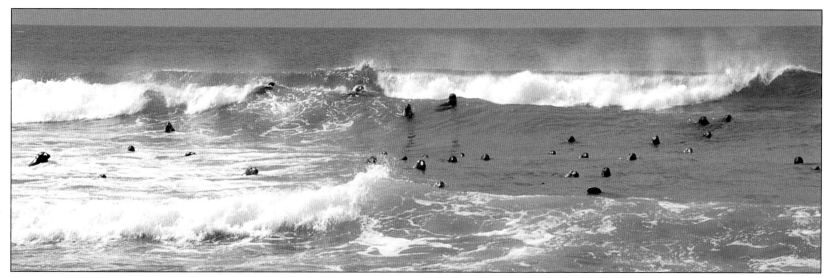

Upper: On a bleak, sleety day Great Black-backed and Herring gulls light on the wide, wind-swept flats of West Spit well beyond the last dunes.
Lower: Grey seals cavort in the waves. Opportunistic feeders, Greys have been recorded diving to depths below 250 metres in their quest for food.

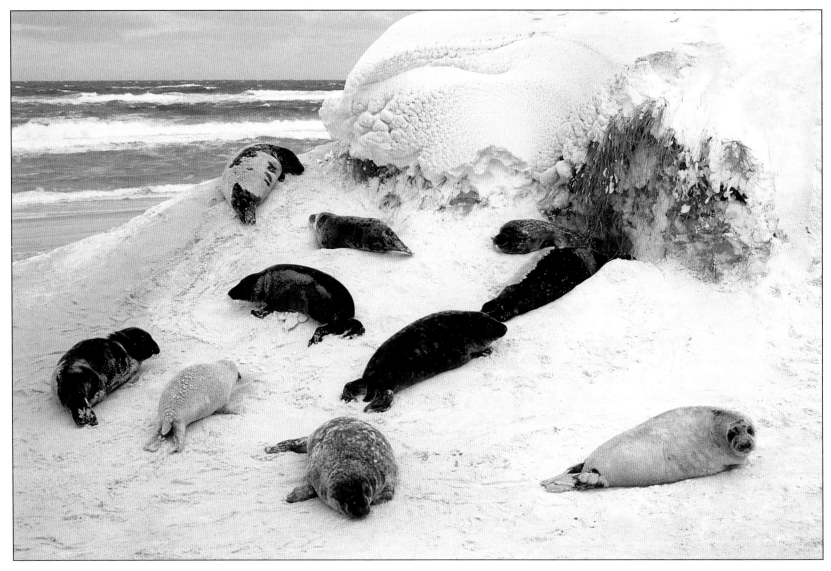

On the edge of a snow-covered dune within sight and smell of the sea, weaned Grey seal pups congregate. The moulted young males have a deep black-grey coat with a few scattered light grey spots while the pelage of the moulted females is the opposite — silver-grey accented by small dark spots.

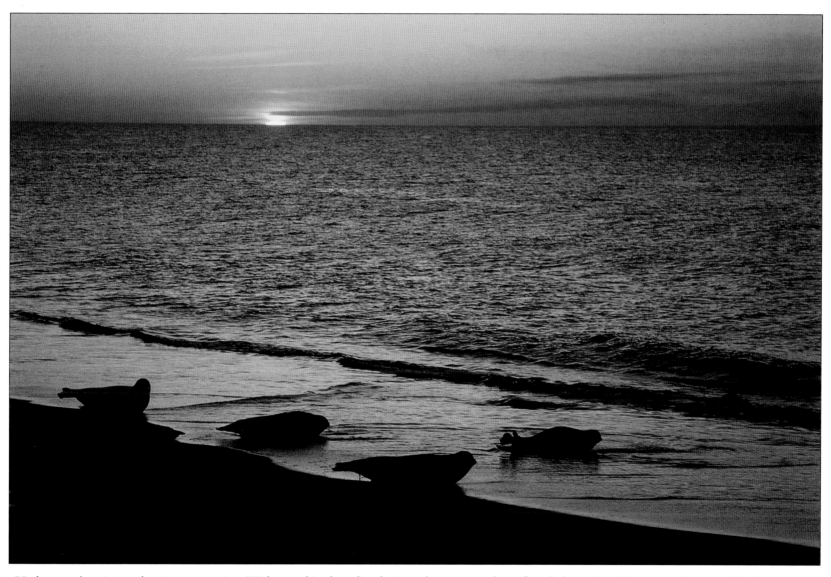

Harbour seals enjoy a calm August evening. Widespread in their distribution, these mammals are found along Canada's entire Atlantic and Pacific coasts, as well as throughout Hudson Bay, in northern Manitoba lakes, the St. Lawrence River, and in isolated regions from the eastern through to the western Arctic.

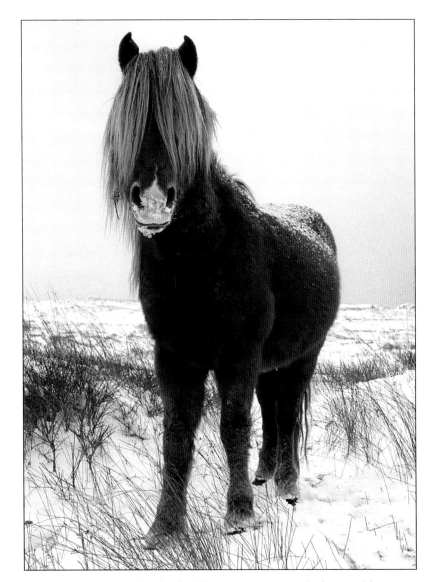

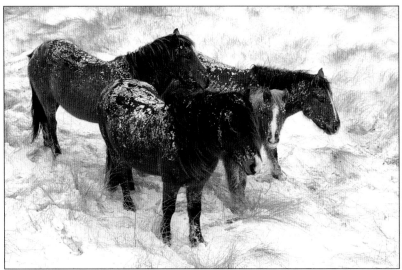

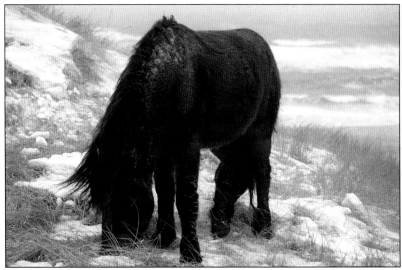

Forelocks, manes, and tails of stallions are exceptionally long. Oldtimers noted that the horses' "manes are long enough for blankets and night caps."

Upper: With rumps to the wind, a herd huddles together waiting out a blow.
Lower: Beach Grass, also called Marram, is the mainstay of the horses' diet.

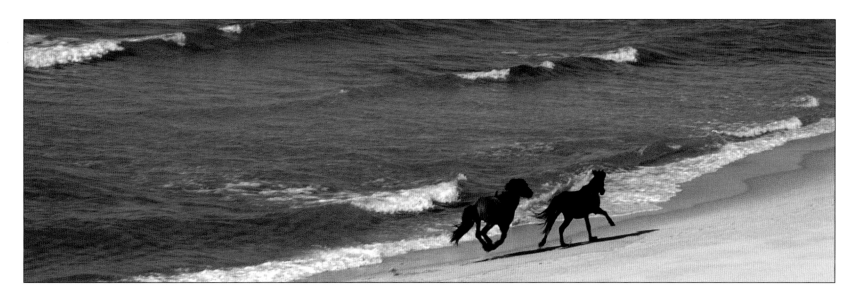

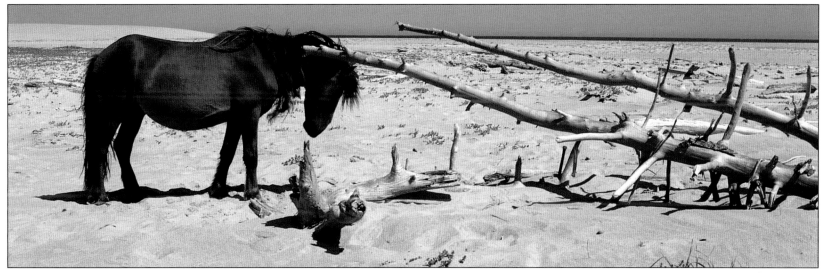

Upper: Filly, *at full stretch*, and stallion. As herd stallions do not mate with their offspring, fillies are banished from the herd to be claimed by other males.
Lower: On an island without trees, driftwood from the mainland over 160 km away serves as a handy scratching post for hide and matted mane.

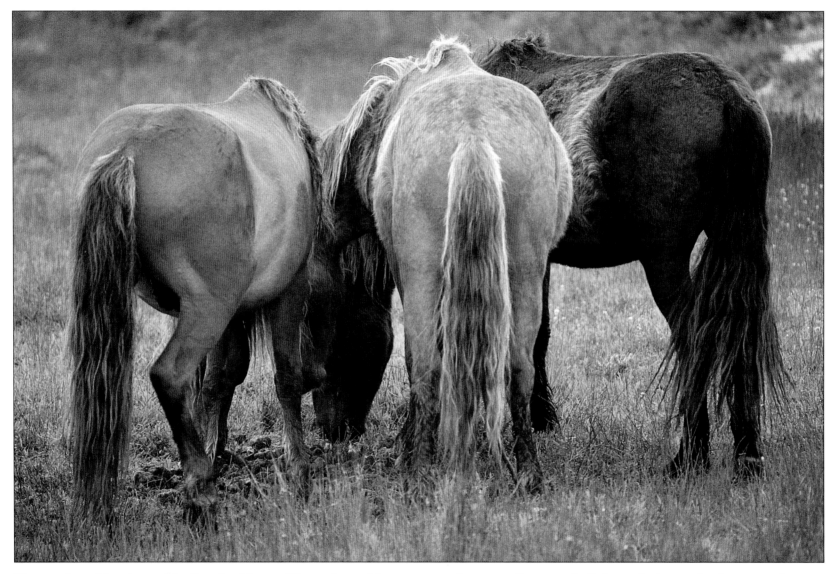

Three males, whinnying and jostling shoulders, sniff one of several large communal manure piles strategically located wherever herds commonly pass: along trails and near waterholes. Highly ritualized marking and display behaviour exists among the stallions to acknowledge superiority and challenge.

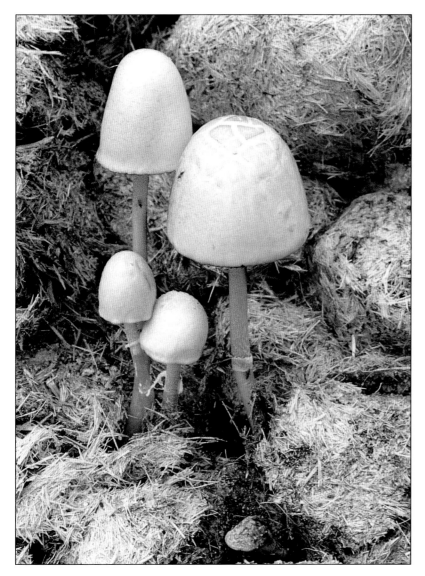

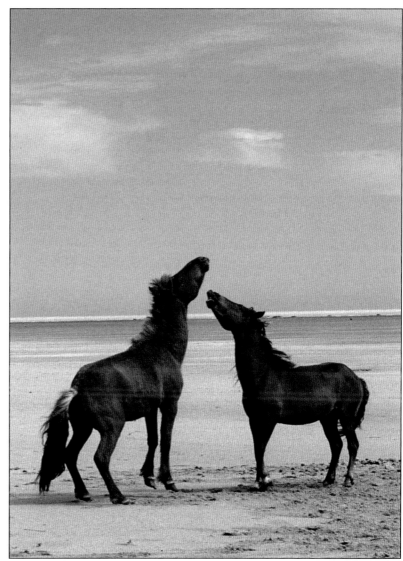

Seemingly overnight, mushrooms appear in the horse dung. The mycelia break down the matter, releasing elements that enrich the sandy soil.

Ritualized threats of significant stares and bluff charges progress through, if necessary, to frontal two-legged boxing and double hind-leg kicks.

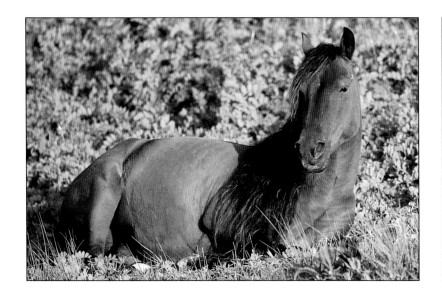

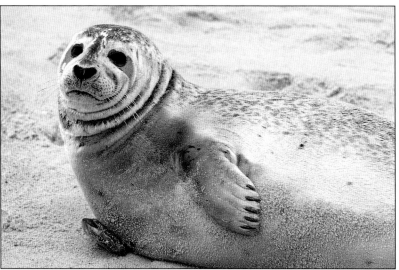

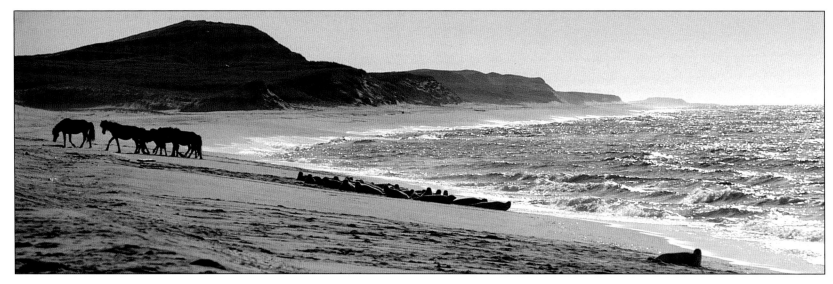

Upper Left: Luxuriating in the warmth and abundant forage of summer.
Upper Right: A Harbour seal, with its distinctive heart-shaped nostrils.

Lower: Late on a sultry summer afternoon horses and Harbour seals share a pleasant stretch of North Beach between East Light and Bald Dune.

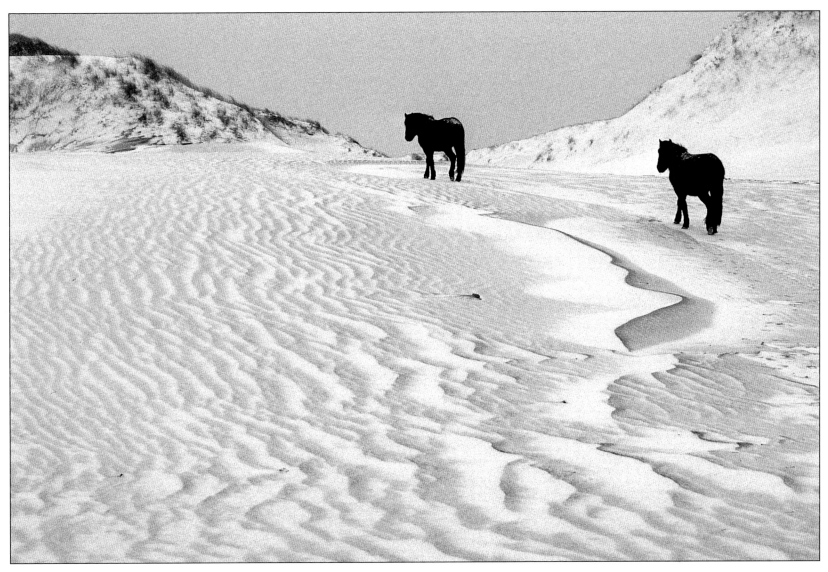

Two horses leave North Beach to climb a wind-rippled pass between dunes. As winter progresses and the soddening, bone-chilling rains of early spring commence, the horses consume most of their stored summer body fat, becoming noticeably thin. The weak die from hypothermia and starvation.

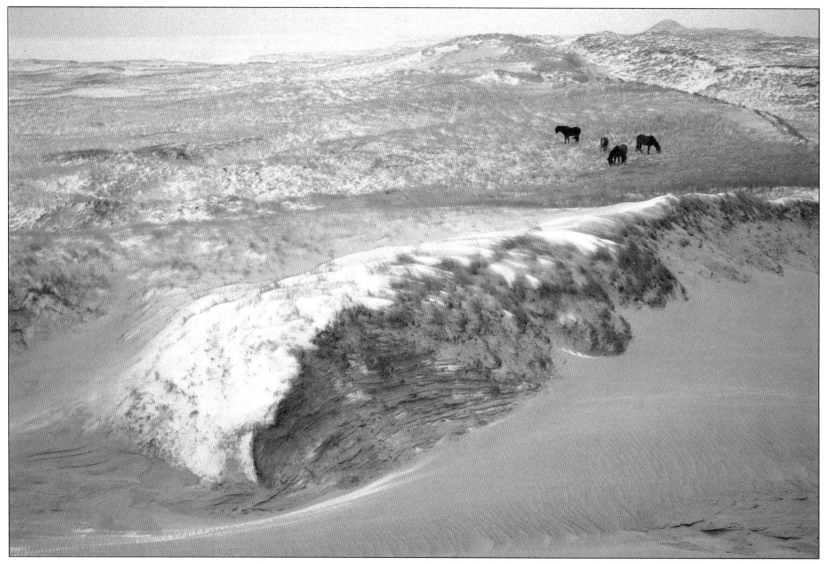

Sable's first known introduction of horses was in 1738 by Rev. Le Mercier of Boston. His Sable farming operation ceased in 1753 and records are unclear as to whether all the animals were removed by Le Mercier or raiding fishermen. Perhaps a few remained, predecessors of today's wild horses.

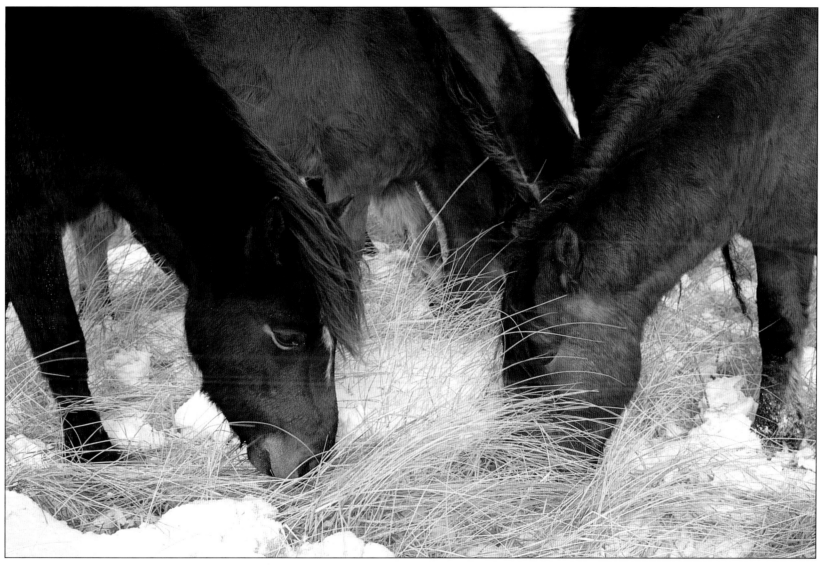

Constantly grazing throughout the short winter days, horses use their hooves to free the Marram from snow and frozen sand. During past times of severe weather, misplaced compassion led to attempts at feeding imported hay. The unfamiliar feed, heavy with human scent, was rejected and urinated upon.

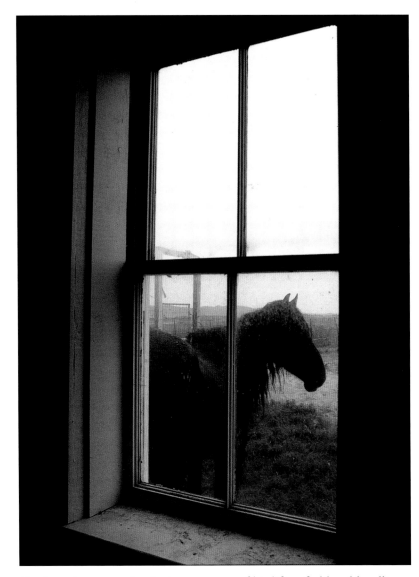

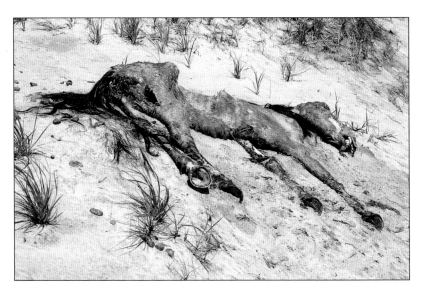

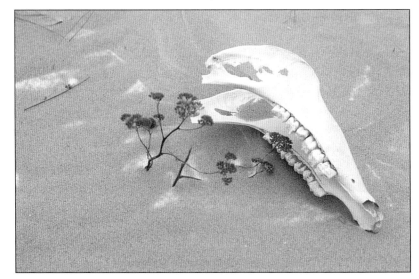

During what was to be the last summer of his life, a feeble, old stallion takes refuge from a storm in the meagre shelter provided by a building.

Upper: Mortality rates are high in the spring, when body reserves are low.
Lower: Eliminating the weak is nature's way of ensuring a strong population.

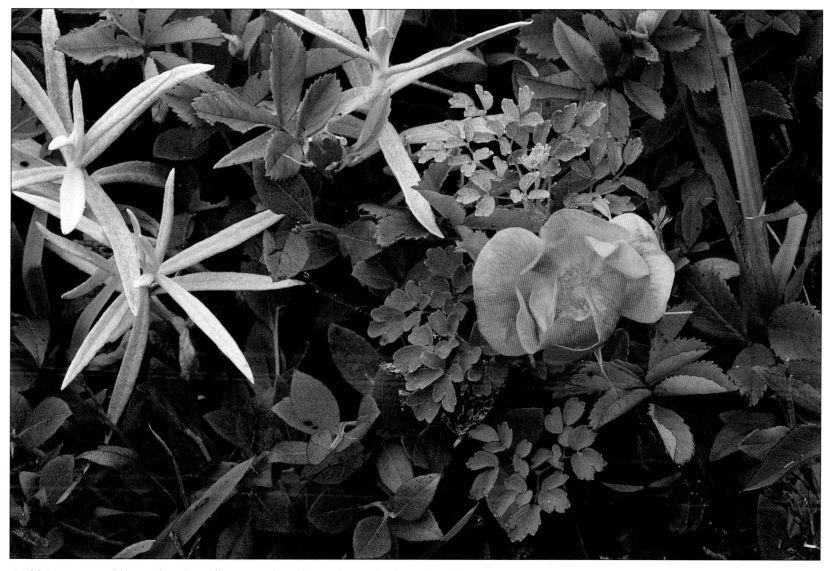

Wild Rose, stunted by wind, and woolly-textured Pearly Everlasting lend touches of beauty to the most stabilized of plant communities, the woody Shrub Heath ecosystem. Covering only four per cent of the interior, these heavily vegetated tracts also include Horizontal Juniper and the fragrant Bay Berry.

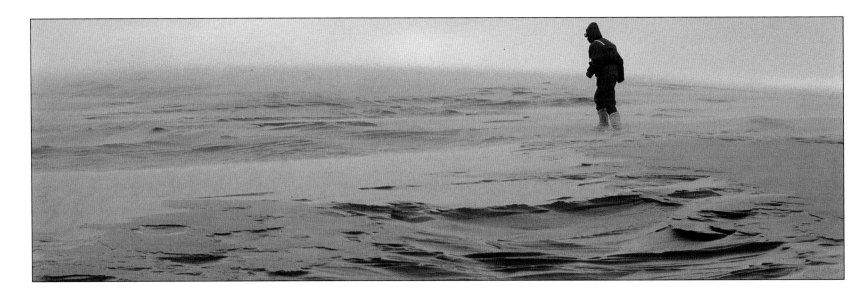

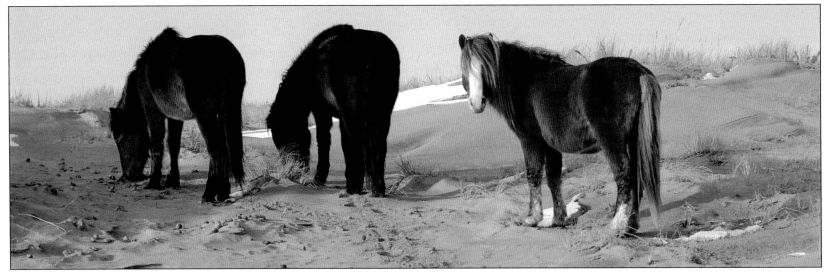

Upper: Violent gale-force winds carry stinging sand that lashes the summit of Bald Dune, etching the hard, frozen dune surface in fanciful patterns.
Lower: Typical colouring of Sable horses is seen in these two bays, with dark manes, tails, and legs, and the chestnut with golden mane and tail.

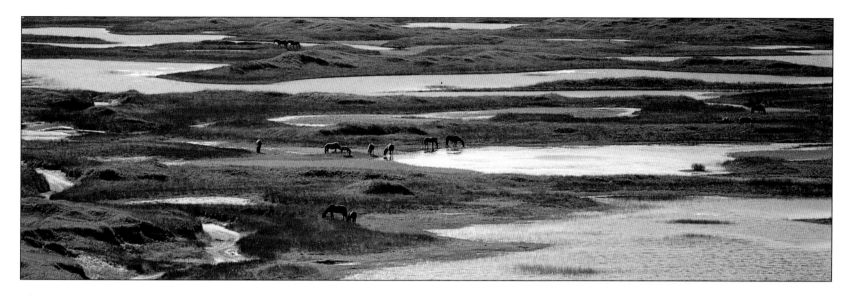

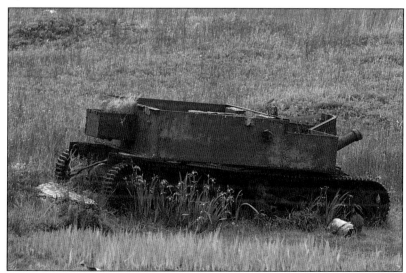

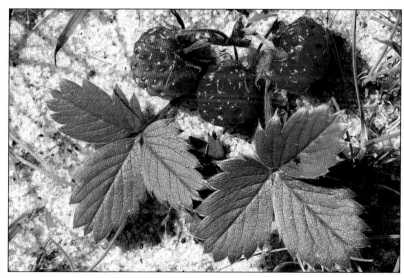

Upper: In Sable ponds live freshwater sponges, organisms found nowhere else on Earth. The island is also host to two unique species of insects.

Lower Left: An old Bren gun carrier once used to pull a wagon and lifeboat.
Lower Right: Wild Strawberries grow amid rounded grains of quartz sand.

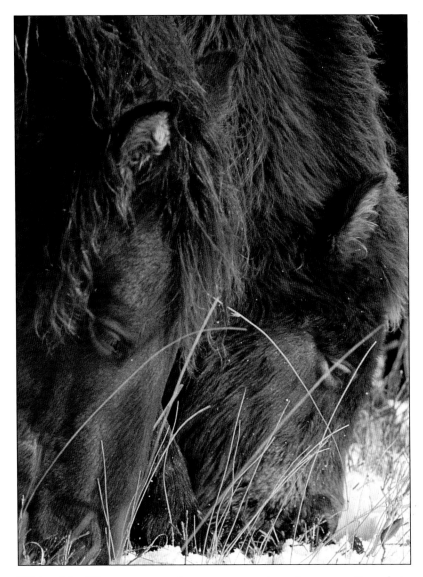

With colder fall temperatures, horses start growing winter coats. Long hair on their lower jaws cause their heads to appear disproportionately large.

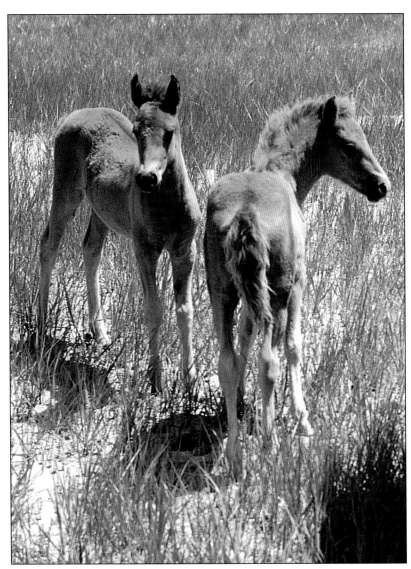

A pair of frisky foals in the sparse Marram out on West Spit. The vast majority of foals is born between April and July, as were these two.

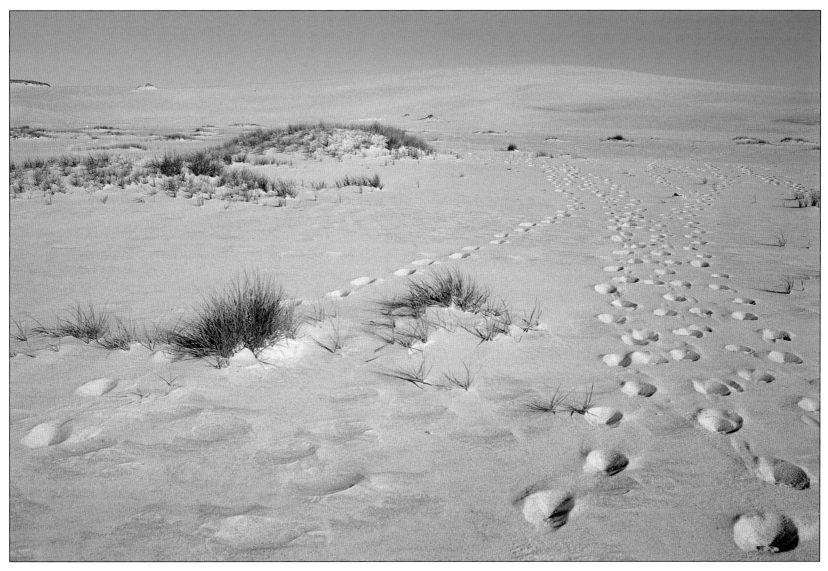

Horse tracks lead toward distant Bald Dune, a large, barren, round-topped sand dune. Bald Dune has formed as a result of winds sweeping from all directions, forcefully blowing quantities of sand up along its slopes and creating an environment hostile to even the tenacious, pioneering Marram grass.

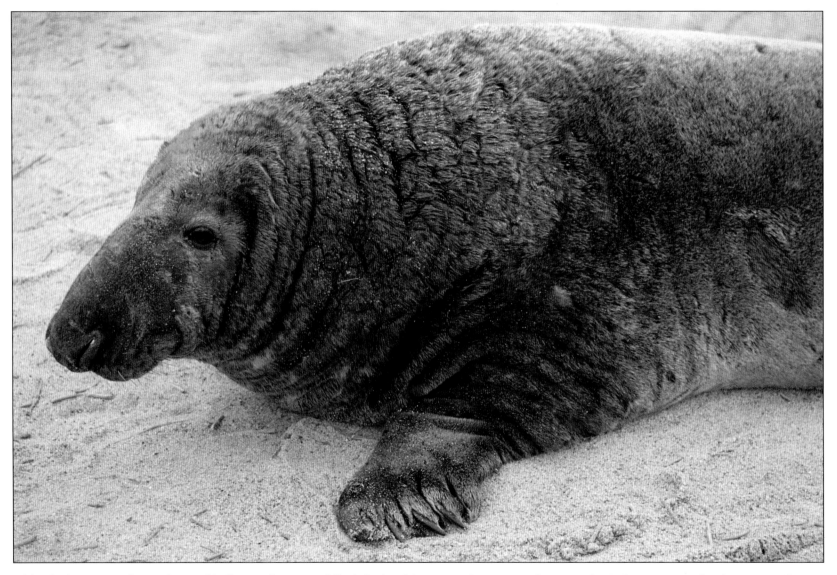

A bloodied, yet magnificent, Grey seal bull rests after successfully defending his territory from an interloping male. Each year accumulated scar tissue from healing wounds functions to increase the bull's overall bulk and subsequent threatening appearance. At 450 kg, the male Grey is Canada's largest seal.

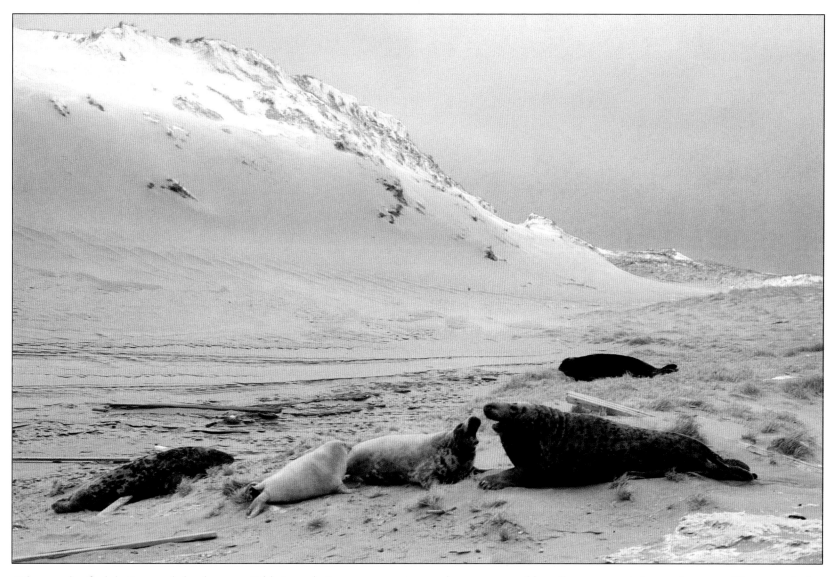

Thousands of adult Grey seals haul out on Sable in early January, returning to the same general breeding area used the previous year. They remain for about three weeks, without feeding, while pups are born and nursed, and mating takes place. Bulls establish territories and claim all cows within reach.

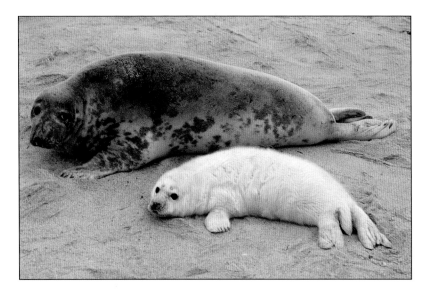

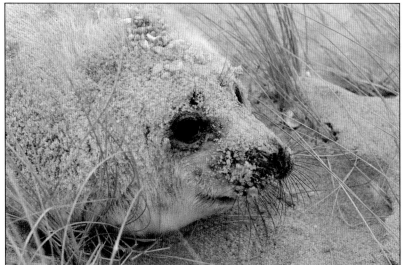

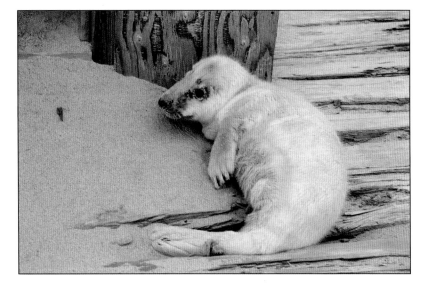

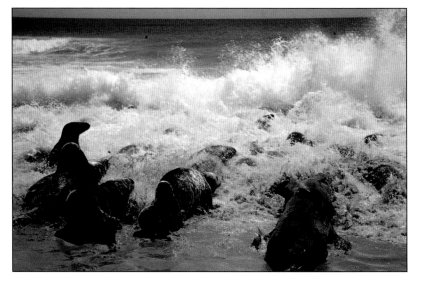

Upper: A lean Grey seal cow, low on blubber, rests with her fattened pup.
Lower: A small orphan, beginning to moult by the nose, finds shelter.

Upper: A weaned Grey seal pup, natal hair matted with sand and snow.
Lower: Greys are known as Horseheads because of their elongated snouts.

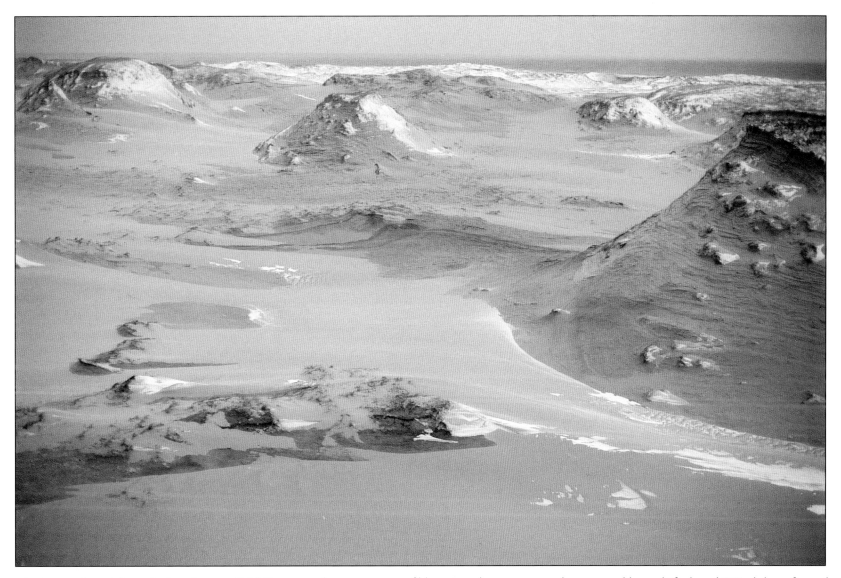

A view southward from the interior near Bald Dune reveals a moonscape of blown-out dunes, steep sand-scarps, and loose drifted sand. Winds have formed a widening trough, which further channels air flow. The sharply-crested dune ridge, *at right*, is being undermined and Marram is toppling down the slope.

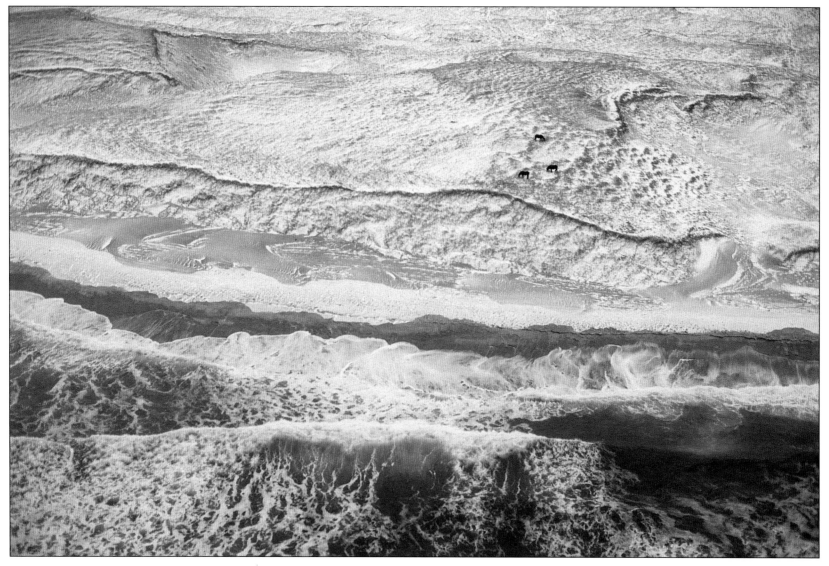

Huge combers roll ashore as three horses browse atop a coastal dune where snow cover is minimal. Ideally suited to the demanding conditions of life on Sable, the wild horses seem to have the savvy attributed to the early horses of New France, those brought to Nova Scotia by French settlers in the 1600s.

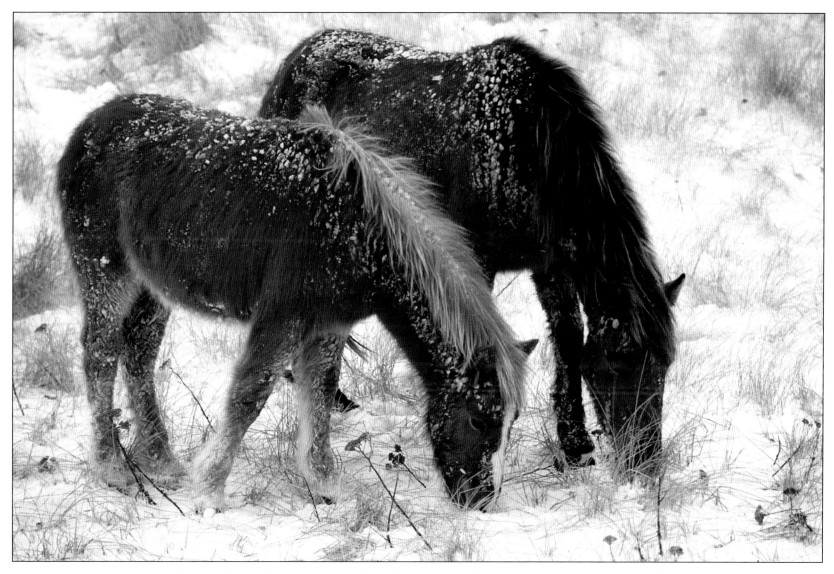

Regardless of whether any of Rev. Le Mercier's horses remained on Sable, a large infusion of animals was brought to the island by Boston merchant Thomas Hancock sometime about 1755-60. These dates closely coincide with the infamous expulsion of Acadians from their lands in Nova Scotia.

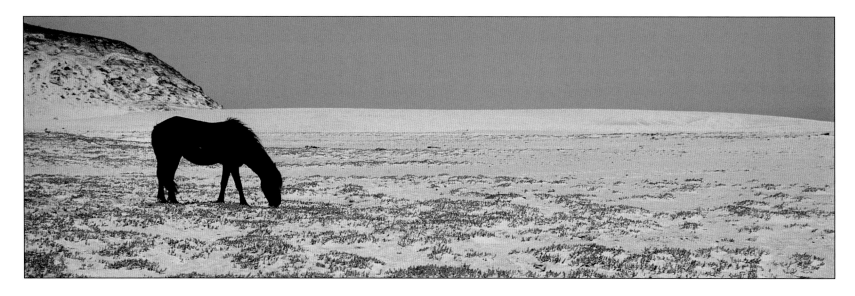

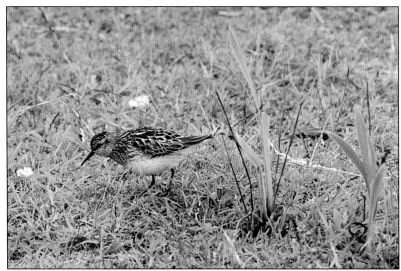

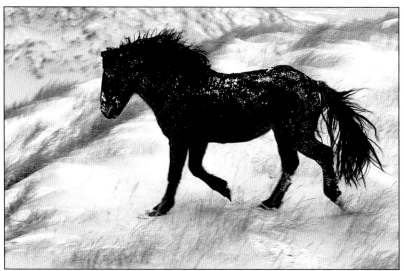

Upper: Near Long Dune, a dark bay stallion nibbles on Seabeach-sandwort, a fleshy plant that stores water and resists sandblasting, traits similar to cacti.

Lower Left: The Least Sandpiper nests on Sable and across subarctic Canada.
Lower Right: The horses are very sure-footed on the soft, uneven terrain.

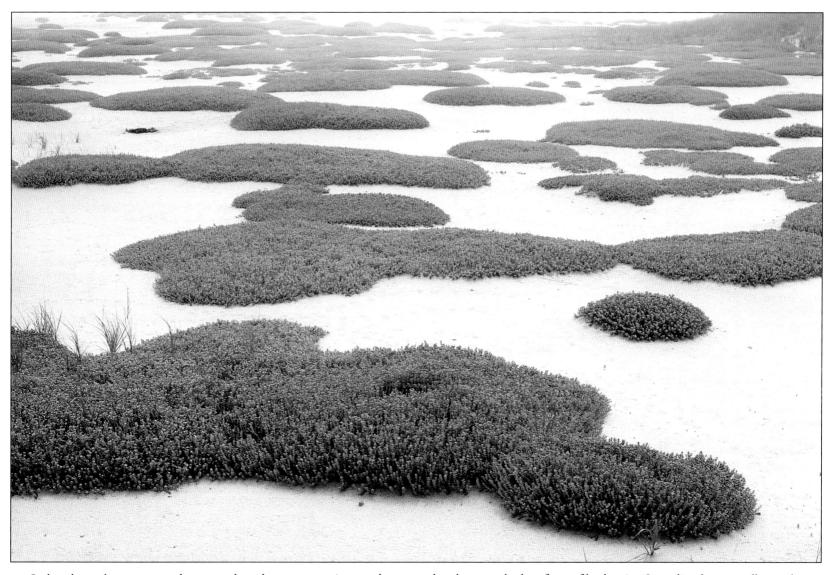

Seabeach-sandwort grows where no other plants can survive, on the exposed and overwashed surfaces of both spits. Spreading horizontally, sandwort withstands frequent inundation by salt water and scouring by waves that flow around the hummocks, leaving roots relatively undisturbed.

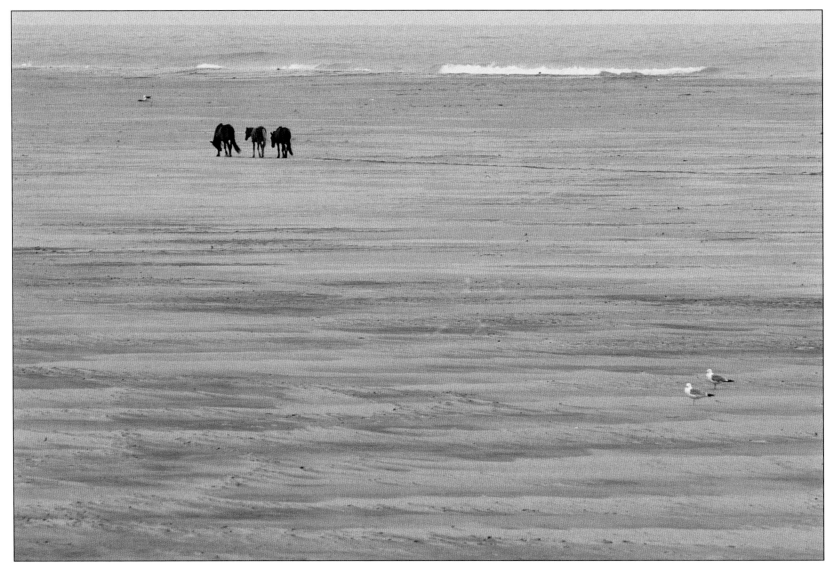

Bachelors cross Wallace Flats headed toward South Beach. In summer, horses often lap the salty foam found at the surf-line. As no calcium exists on Sable, other than a little found in plants, the horses likely supplement their diet with minerals from the sea, similar to other ungulates that frequent salt licks.

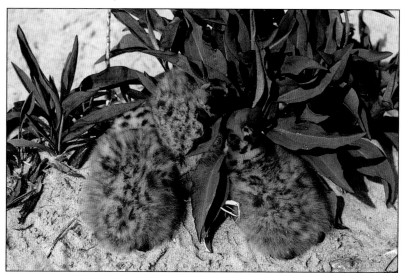

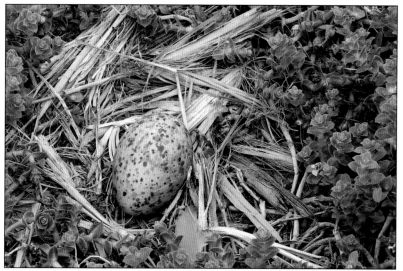

In less windy areas, mats of Beach Pea blanket the sand. Bacteria present in the plant's root nodules convert airborne nitrogen into useable nitrate.

Upper: Herring Gull chicks huddle among emergent goldenrod leaves.
Lower: A gull nest, scooped out amid sandwort, contains a cracked egg.

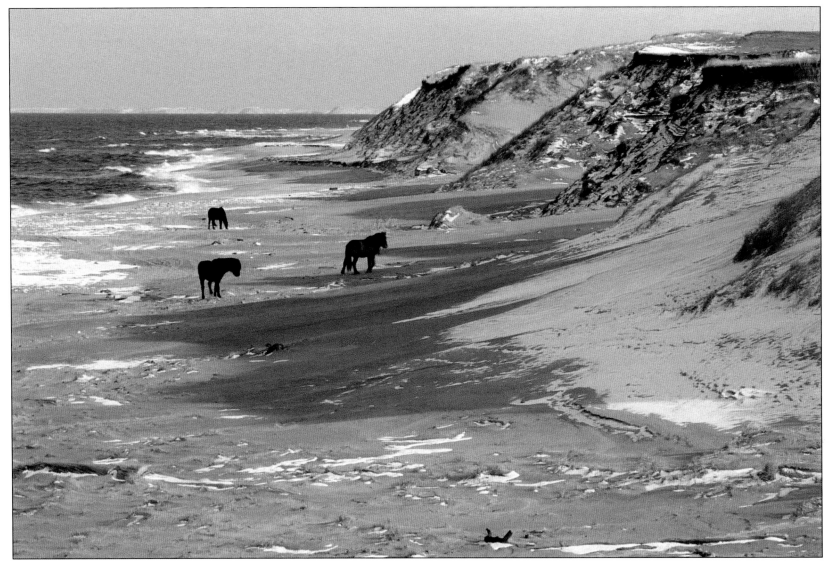

The warm wash of late afternoon light on beach and dune belies the fact that the weather is bitterly cold. Before the founding of lifesaving stations in 1801, death from exposure more often than not greeted the shipwreck survivor unfortunate enough to be cast upon Sable's hostile shores.

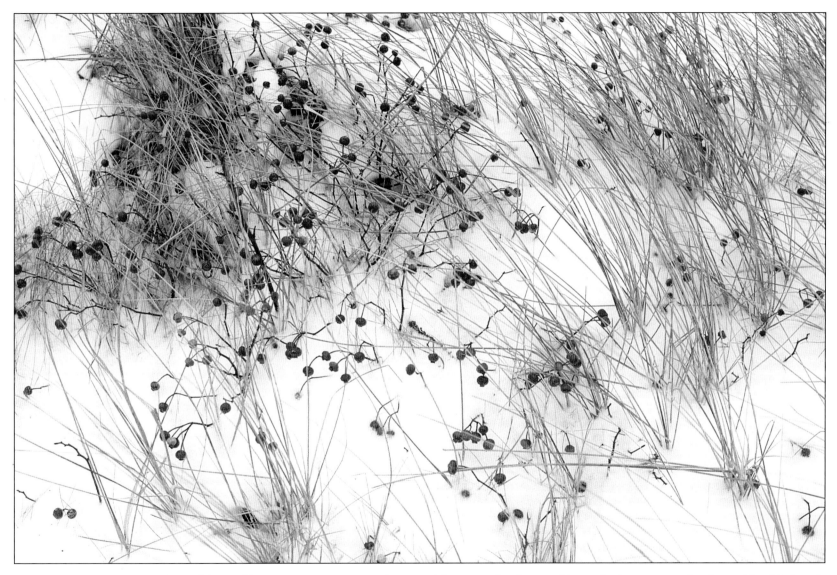

On a crisp winter's day hips of the Wild Rose, *Rosa Virginiana (see page 67),* create a bright sprinkling of colour among the dry, golden blades of Marram growing on the south side of a dune near old Main Station. Bright red hips were once gathered to make a tasty and nutritious jam.

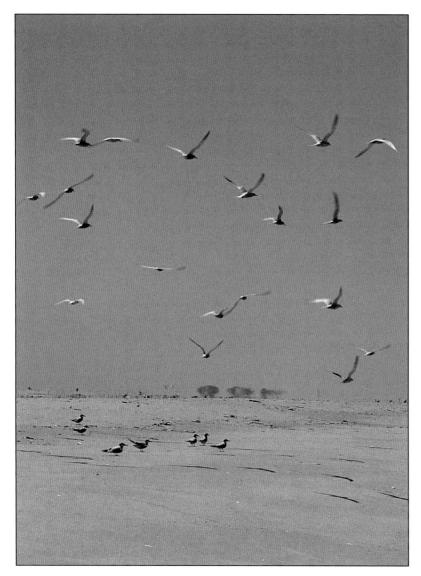

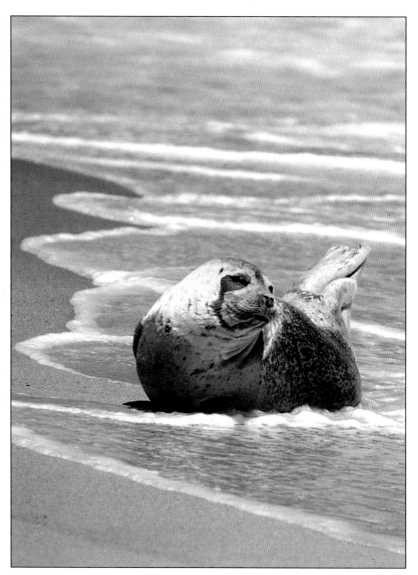

Terns take to the air from the barren sand flats of East Spit. Through summer heat waves, tall dunes to the west appear as distant mirages.

A Harbour seal dozes while surf froths about. On Sable Island is found Eastern Canada's largest concentration of Harbour, or Common, seals.

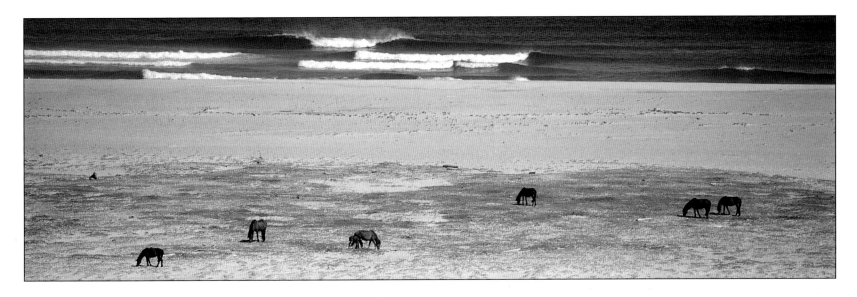

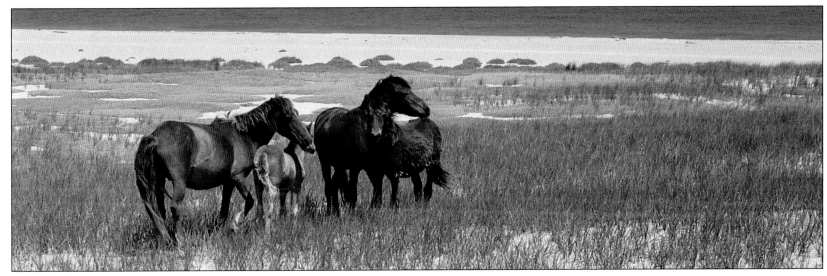

Upper: On an idyllic August day, a herd of horses browses the sparse sandwort as curling breakers thunder ashore on South Beach by Long Dune.
Lower: Two mares, a shaggy yearling, and a foal in the Marram on West Spit. Females first breed about age three giving birth 11 months later.

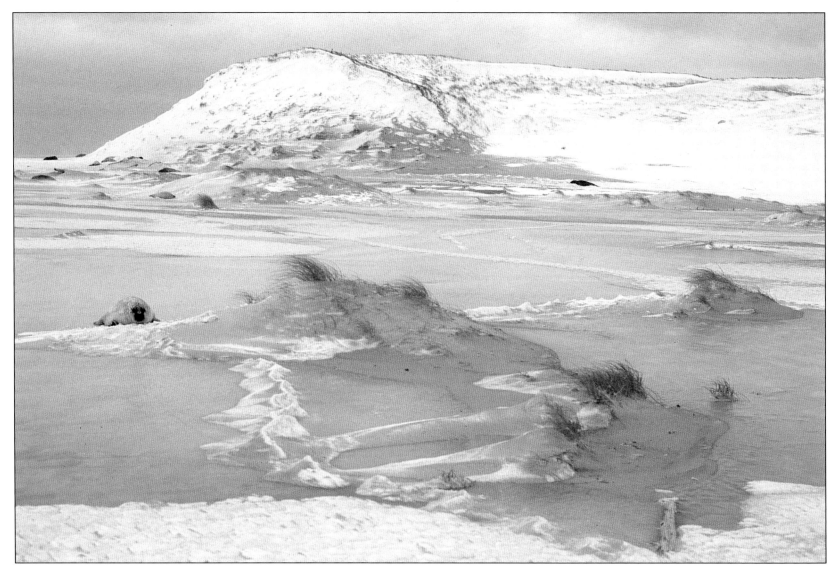

A Grey seal pup rests by a hummock in a frozen pond. More seals lounge about at the foot of the distant dune. A century before, at this same location near Bald Dune, seals were rendered into oil, their hides cured for leather. In 1895, over a thousand skins were taken, as were hundreds of barrels of oil.

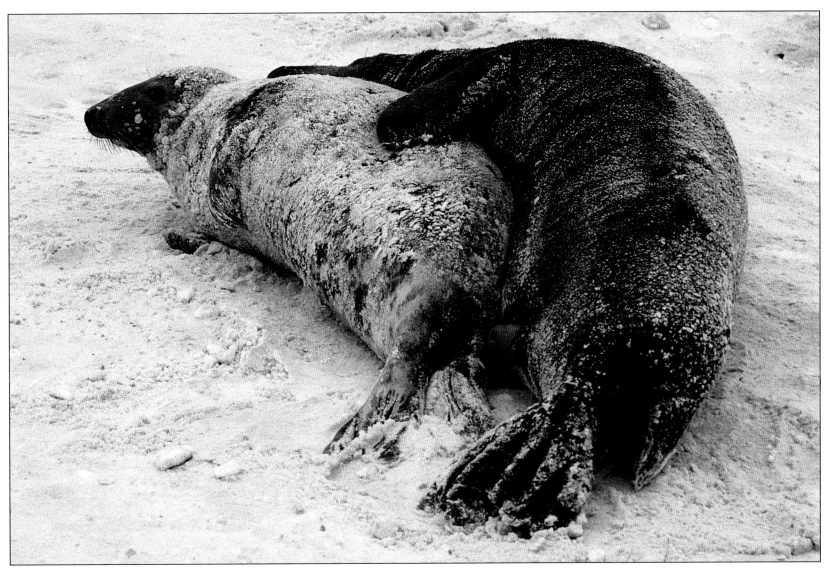

About the time a pup is weaned, Grey seal cows become receptive to the amorous attention of bulls. However, a disinterested female will slash with the sharp claws on her fore flippers and bite, often drawing blood. Ignoring the protest, the male will try again later when, hopefully as above, the cow is more docile.

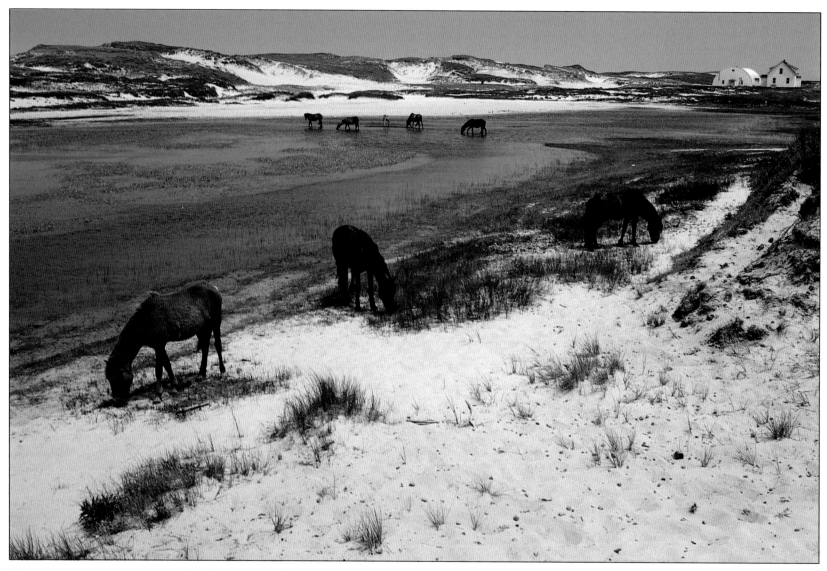

Horses at the freshwater ponds, West Light. Other than a few humans, horses are the only terrestrial mammals on Sable. In 1960, after much controversy, the Government of Canada reversed an earlier decision to sell off the "ponies" and instead passed laws to protect the horses from all interference.

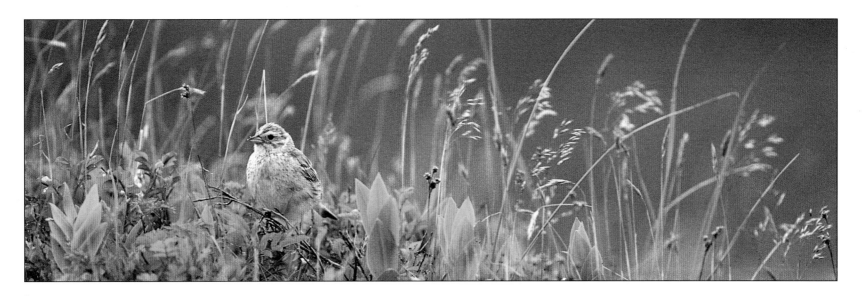

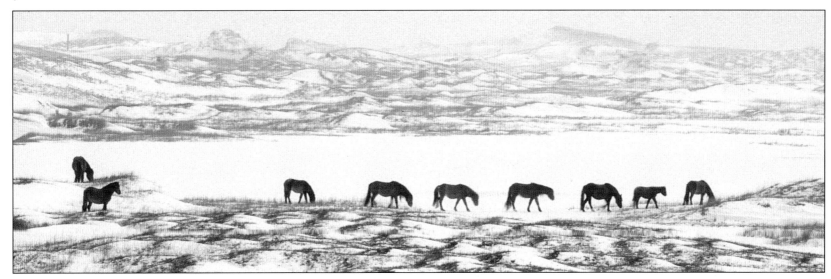

Upper: An Ipswich Sparrow perches on a sprightly tuft. A ground nester, this pale subspecies of the Savannah Sparrow is only known to breed on Sable.
Lower: When ponds freeze hard, horses dig down to water through the insulating blanket of drift snow that accumulates around shoreline plants.

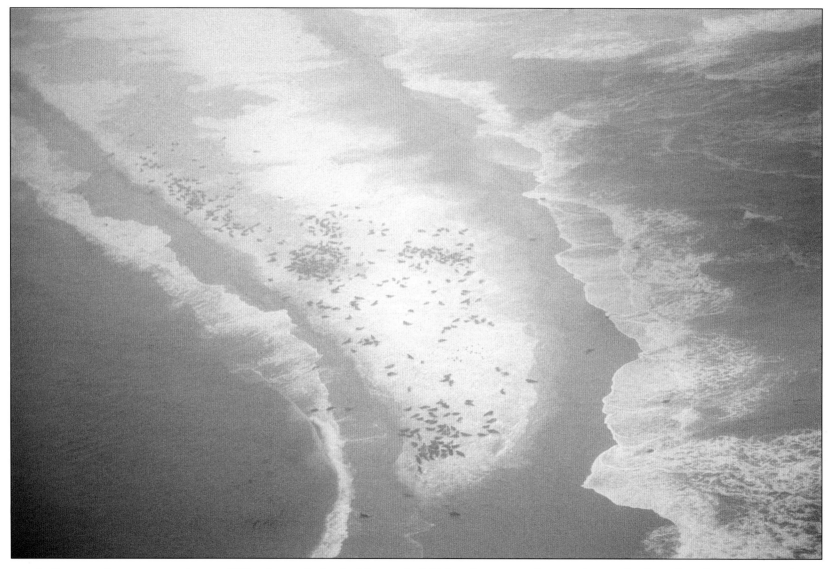

A veil of snow and spray screens the tip of West Spit and a herd of Grey seals. Sable's inclement weather, treacherous shoals, and conflicting currents have caused some 222 shipwrecks recorded since 1801. However, estimates place the total loss much higher, at over 500 ships and thousands of lives.

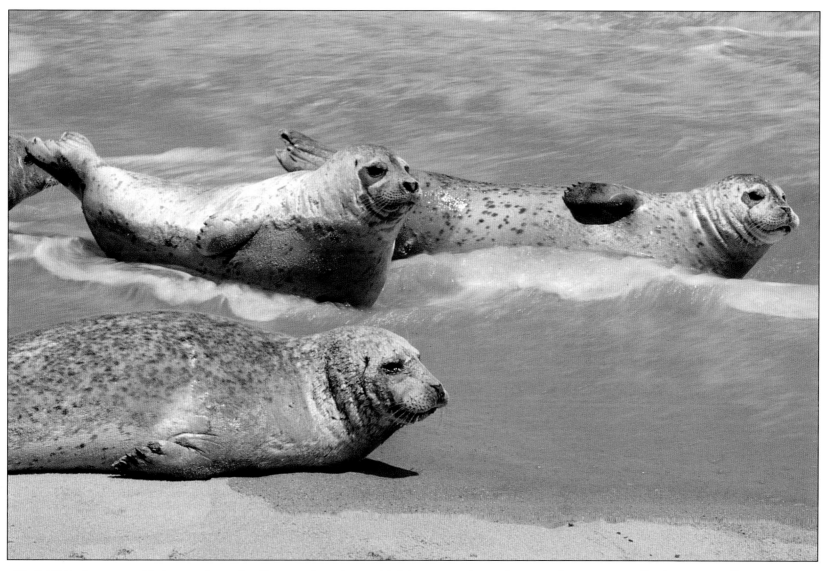

Until 1976 a bounty on Harbour seals was in effect to reduce the specie's fish consumption and presumed transmission of codworm, as well as to minimize seal damage to fishing gear. Studies show, however, that Harbour seals eat an insignificant quantity of fish compared to that caught by commercial fisheries.

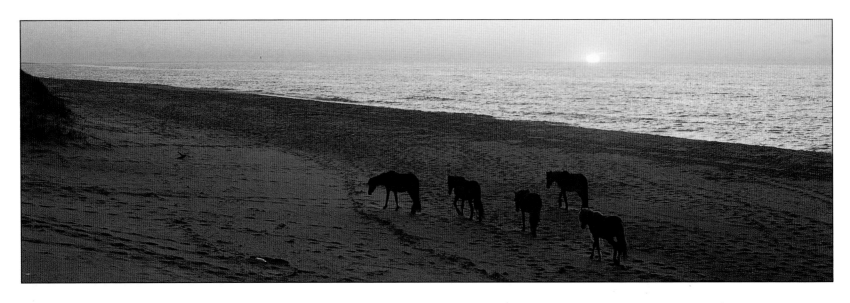

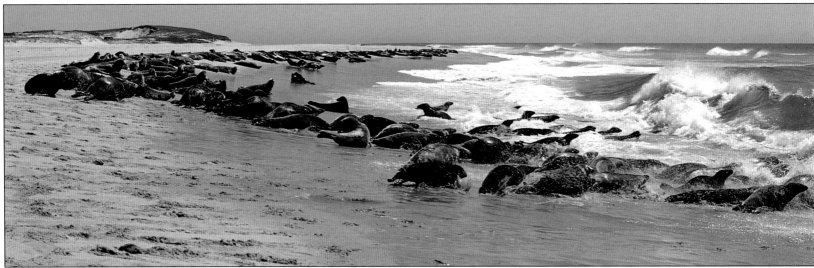

Upper: As the sun sinks below the horizon, a herd of horses ambles along the broad summer beach enroute to their grassy bedding ground inland.
Lower: On South Beach toward Long Dune, a herd of several hundred Grey seals relax, some taking to the water, others hauling out.

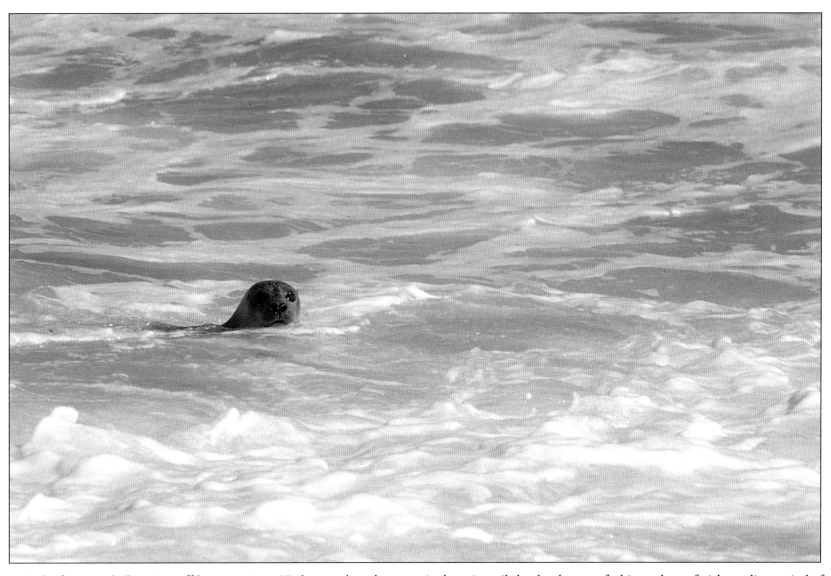

In the foaming shallows just offshore, a curious Harbour seal can be recognized as a juvenile by the absence of white and grey facial mottling typical of adults *(pages 62 and 91)*. Compared to the larger Grey seals, Harbours have small round heads, slightly upturned noses, and heart-shaped nostrils.

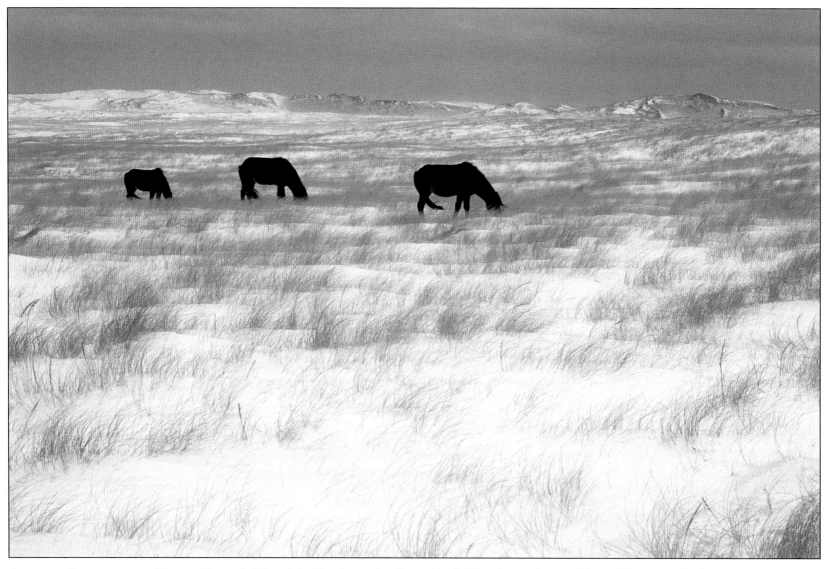

Around 1760, entrepreneur Thomas Hancock shipped Acadian horses (confiscated in the Expulsions of 1755-62) to Sable. Hancock planned to pasture the horses until it was convenient to transport them to West Indies' sugar plantations. He died, however, in 1764, his designs unfulfilled. The horses stayed.

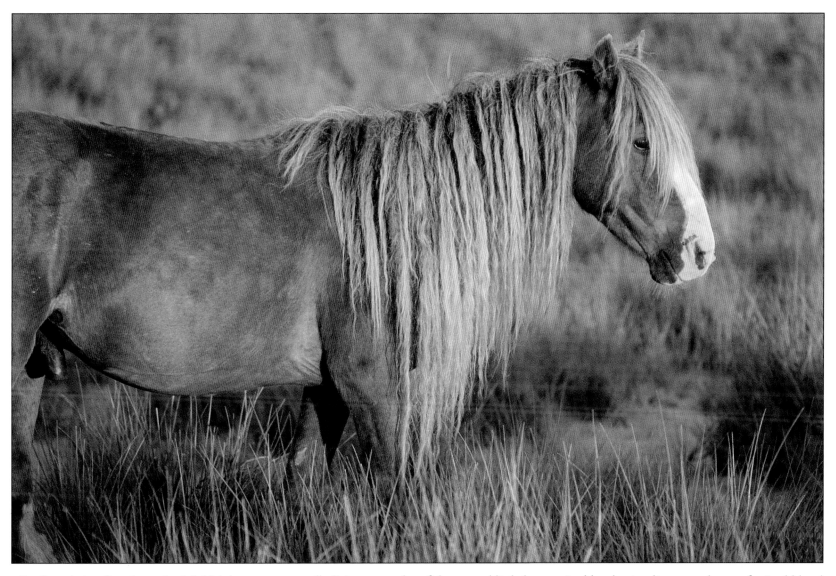

Far from being "scrub ponies," Sable's horses are actually living examples of the rugged little horse raised by the Acadians — a horse of mixed blood with Barb characteristics that could withstand harsh climate, lack of shelter, and poor fare such as were typical conditions of early settlement life.

PAT & ROSEMARIE KEOUGH are a creative husband and wife team who, through the years, have travelled extensively across Canada and around the world enjoying their chosen profession — photography, writing, and book production. Former managers in the corporate world, the Keoughs launched an exciting new career in 1986 with the release of the first artbook to feature their imagery, the bestselling *Ottawa Valley Portfolio*. Several highly acclaimed Keough productions have followed, including *The Nahanni Portfolio*, *The Niagara Escarpment: A Portfolio*, *Beautiful Arnprior*, *Wild and Beautiful Sable Island*, and *Beautiful Renfrew*, as well as their award-winning television feature *The Nahanni and Rebekka Dawn.*

The Keoughs extend a very sincere note of thanks to family and friends who have assisted them, and especially to Bob & Birgit Bateman, Fred & Lynn Baechler, Donald & Lucy Bethune, Jacques Blanchette, Conrad & Bernice Byers, Mary-Louise Byrne, Arvid Chalmers, Barbara Christie, Jerry & Judy Conway, Flora Czirfusz, Peter Evans, Dave Fisher, Ian Fraser, John Hanley, Michael Harper, Cyril & Annette Keating, Gerald & Mary Keough, Anne Mettam, Don Moore, Mary Mortimer, John & Jennifer Okell, Mary Jane Peters, Neil Pinsent, Karen Smith, Dan Soucoup, Chella Stephens, Lillian Thomson, and Ruth Tobin.

The historical photographs were kindly shared courtesy of:
Lillian Thomson: All photographs by Trixie Bouteillier. Page 7 lower; page 8 upper, lower left, lower right; page 9 upper left, lower left; page 10 upper, lower left, lower right; page 12 upper, lower left, lower right; page 13 lower left, lower right; page 14 left and right; page 15 upper, lower left, lower right.
Canadian Coast Guard: Page 9 right.
Maritime Museum of the Atlantic: Page 11 N-16038; page 13 upper N-16044; page 16 N-16416 courtesy of the Bell Family, photograph by Arthur McCurdy, National Geographic Society.

WILD AND BEAUTIFUL SABLE ISLAND

Planning & Logistics	Pat & Rosemarie Keough John Major, Canadian Coast Guard
Photography, Research, Writing, Design & Publishing	Pat & Rosemarie Keough, Nahanni Productions Inc.
Artwork & Cartography	Douglas Penhale
Editing	Heather Lang-Runtz
Proofreading	Mary Keough
Type Output	Tony Gordon Limited
Colour Separation, Printing & Binding	Toppan Printing Co., Ltd.